MOM'S
LITTLE BOOK OF
PHOTO TIPS

Lisa Bearnson

and

Siobhán McGowan

CREATING KEEPSAKES BOOKS
Orem, Utah

A child's well-being is more important than a photograph. When taking photos inspired by this book as well as at all other times, use your own judgement to ensure your subject's safety. Also employ common sense in caring for your camera to guard against damage by water, sand, heat, and sunlight. The publisher is not responsible for any damages resulting from the use of this book.

Published in 1999 by Creating Keepsakes Books, a division of Porch Swing Publishing, Inc., 354 South Mountain Way Drive, Orem, Utah 84058, 800/815-3538. Visit us at www.creatingkeepsakes.com.

PRINTED IN THE U.S.A.

Library of Congress Cataloging-in-Publication Data

Bearnson, Lisa.
 Mom's little book of photo tips / by Lisa Bearnson and Siobhán McGowan.
 p. cm.
 Includes index.
 ISBN 1-929180-12-8 (alk. paper)
 1. Photography Amateurs' manuals. I. McGowan, Siobhán. II. Title.
III. Title: Mom's photo tips
 TR146 .B38 1999
 778.9'25—dc21 99-39153
 CIP

Creating Keepsakes Books may be purchased in bulk for sales promotions, premiums, or fundraisers. For information, please write to: Special Markets Department, Creating Keepsakes Books, 354 South Mountain Way Drive, Orem, Utah 84058.

Thank you to the many readers who offered suggestions and expert advice on this book, including writers Jana Lillie, Deanna Lambson, and Gayle Humphreys, and photographers Jim Mairs, Fred J. Maroon, and Barbara Peacock. And special thanks to all the moms who participated in this project. They shared their best tips as well as their terrific photos!

Creating Keepsakes Books
Washington, D.C. office
Book Program Director:
Maureen Graney/Blackberry Press, Inc.
Art Director: Susi Oberhelman
Production Consultant: Kathy Rosenbloom
Editors: Erin Michaela Sweeney
 Charles D. Anderson
Index: Pat Woodruff

Front cover photograph: Michael Schoenfeld, Salt Lake City, Utah
Back cover photographs: Deanna Lambson (top), Carol. A. Cousins (bottom)

Creating Keepsakes™ scrapbook magazine
Editorial Director: Lisa Bearnson
Creative Director: Don Lambson
Publisher and CEO: Mark Seastrand

Creating Keepsakes™ scrapbook magazine is published ten times a year. To subscribe, call 888/247-5282.

Got Tips? We'd love to hear from you! If you've got great "mom" tips that you'd like to share—about taking great pictures (color or black and white), celebrating holidays, having fun with the kids, parenting, keeping balance in your own life, or anything else—and would like to share them with other moms, write to us and maybe we'll use your idea in a future publication! All submissions become the property of Creating Keepsakes and cannot be returned. Due to the volume of mail, personal responses are not possible. Write to: Creating Keepsakes Books, a division of Porch Swing Publishing, Inc., 354 South Mountain Way Drive, Orem, Utah 84058. Website: www.creatingkeepsakes.com.

HERE'S TO

THE FAMILY PHOTOGRAPHER

MOM

I dare you. No, I double dare you to take the "who's the real photographer in your family" challenge. Write the names of each of your immediate family members on a piece of paper, grab 100 recent photos, and count how many times each member of your family appears in them. I'll bet your children are in 90 percent of the photos, your husband in 50 percent, and you—well, you'll be lucky to be in 10 percent of them.

I first noticed this trend several years ago. After spending hours trying to find a decent snapshot of me for my son's "star of the week" school poster, I realized that I was missing from most of the family pictures. "I'm always the one behind the camera," I told my husband. He disagreed, and that's when I showed him the proof: my children's faces were in 84 photos, my husband appeared in 36 and I was in a measly eight. My husband finally agreed that I wasn't in many of the pictures because I was the one taking them. "Okay," he said, "I concur that you're the photographer in our family." When asked why he rarely takes pictures, he smiled and said, "I don't like the pressure, plus you're so good at getting the best shots!"

As the true family photographer, I knew I had to keep improving my photography and decided to pull together a book of easy-to-follow, proven tips on how to take great pictures of kids with my point-and-shoot camera. I didn't want technical jargon. I wanted straightforward advice on how to capture the magic of my children's lives. I wanted advice that any photographer with any type of camera could follow. Advice on capturing my kids in a captivating nature setting. Advice on taking great group shots, using the perfect props in photos, or capturing great water shots. I wanted advice on virtually every scenario I'd come upon when taking pictures of my kids. So who did I go to? Moms! This book is a compilation of all their wonderful advice. It's the only book from moms, for moms.

If, like me, you find yourself behind the camera most of the time, enjoy it! You're the family photographer, and you are helping document the facts, the frenzy, and the fun of your family's day-to-day experiences. It's actually quite an honor, and armed with the advice of what works best for other moms who take a lot of pictures, you're bound to capture many of life's happiest memories. That's a great gift to give your family.

LISA BEARNSON

CONTENTS

A DAY IN THE LIFE
CANDID PHOTOS
OF YOUR CHILD

56

FUN AND
IN THE GREAT OUTDOORS
GAMES

66

GATHER
GROUP PHOTOS
TOGETHER

84

Don't be scared by the word "portrait." It's just a picture of a person! Natural-looking shots of people you care about are the most satisfying kinds of photographs to get back from the developer. All the tips in this chapter are ideas for different ways to take portraits of your children.

Most of us own automatic or point-and-shoot cameras, both named for their great time-saving features, automatic focus and automatic flash. But what if your camera is a single lens reflex (SLR)? You can use all the tips in this book with an SLR (some of the pictures in this book were taken with SLRs). Many have autofocus and, even if they don't, it's not hard to learn to focus them. With an SLR, you control your depth of field with f-stop adjustments, which change the diameter of the lens opening (larger aperture lets in more light with less depth of field, smaller aperture lets in less with greater depth of field).

With a point-and-shoot, the film you use determines the depth of field you get. My favorite film is ISO 200 and

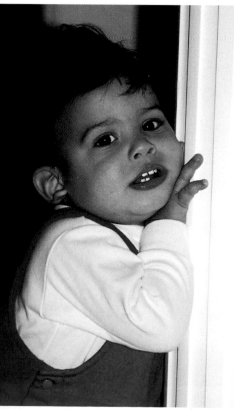

Sandra O. Aguirre

In this three-quarter-length portrait, sidelighting creates soft, pleasing contrasts of shadow and light.

I almost always use my flash, indoors and out. This film, or an even slower one such as ISO 100, gives you clear, crisp pictures with pleasingly blurry backgrounds. The camera automatically sets a wide aperture, trying to let in all the light it can. When I use the flash, it helps the film do its best. See the picture of Kade and Collin on page 31 for a good example of the results I get with

color photos look green. If you have to take pictures in, say, a gym, see if there's any source of natural light around and move your children close to it. Or, get close enough (within six feet) so your flash lights them. Another solution, if you have a flexible film lab, is to ask them to reduce the green overall when they print your pictures. And if you know you have to take a lot of pictures under fluo-

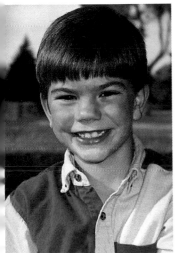 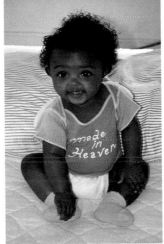

Shauna White Gale A. Johnson-Peltier Nancy Freeman

this combination of film and flash.

If you want more depth of field with a point-and-shoot, on the other hand, try using a faster film, such as ISO 400 or 800. You may also have better luck in low-light conditions or experimenting with natural light using this faster film. The trade-off is that the prints will look slightly grainy, but this can add atmosphere to your photos.

Lighting is the crucial factor in photography. Fluorescent light is the most difficult to work with because it makes

Indoors, outdoors, head-and-shoulders, full body: All are portraits.

rescent lights, such as for a child's karate class, try doing a series with black-and-white film. Problem solved!

Take lots of photos and learn from your experiments. With a little practice, you'll soon capture the charm and grace of a clean, well-lighted face.

Asleep on a Shoulder

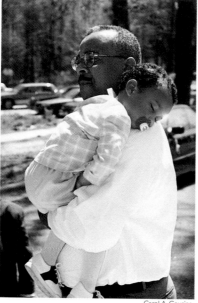

Carol A. Cousins

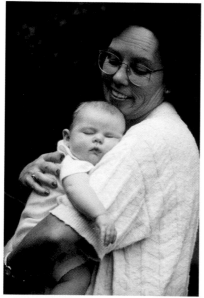

Alyssa Allgaier

The shoulder scenario makes an adorable portrait for babies, toddlers, and even older children. A supportive adult adds a sense of scale. And a dozing little one of any age affords you, the photographer, some creative time. Use those extra seconds to:

- instruct the adult on how to pose
- adjust your position to best take advantage of available light
- consider different perspectives— horizontal, vertical, diagonal, zoom—through the viewfinder
- evaluate the effect background and foreground colors and patterns have on the composed image
- check that there are no distracting elements around the edges of the frame

For an especially intimate look, crop out the adult heads, and shoot a few frames that focus only on baby, nestled peacefully in someone's loving arms.

Fun tip: This position is a great way to photograph babies under six weeks who don't have enough muscle control to hold their heads upright. When they're three or four months, you'll be able to prop baby up in the corner of a couch or upholstered armchair with pillows (for a few carefully watched moments) without the floppy-neck look, but until then, give that baby some support!

A Roll of Black & White Film

aby skin seems perfect, so why does it look blotchy when the color photos come back? One problem: the harsh light of a flash. One solution: black-and-white film.

Every baby deserves a role of black-and-white film. It evens out skin tones and gives portraits a timeless feel. When using black-and-white film:

- use natural light
- move in close to baby's face to avoid distracting details

Given the archival quality possible with black-and-white prints, every

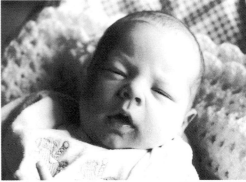

Deanna Lambson

stage of your child's life deserves a roll! Prints made on good paper will last longest.

Maureen Graney

9

Use Natural Light

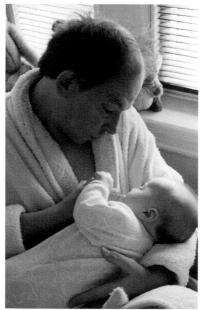

Maureen Graney

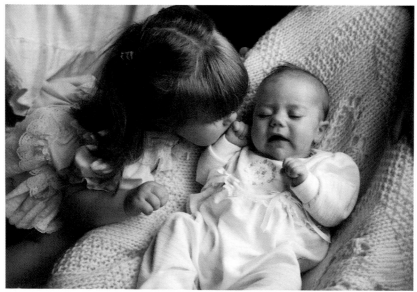

atural light—no camera flashes, no indoor lamps—will keep baby skin from looking blotchy in indoor color photos. Look for a glowing source of light from a strong indirect source (such as a window, as in the photo at left). Even on overcast days, enough light will get inside if it's reasonably bright outside.

- Turn off your camera's automatic flash. The camera won't notice the subtle lighting effect, so it will want to light the shadows!
- Watch where the shadows fall. Surround the baby in a warm glow but avoid dark patches elsewhere.
- Act quickly: natural light changes constantly as the time of day passes.

Shauna White

Stand Directly Above

Photographing a comfortably supine infant by standing directly above is a great way to pose babies who can't yet hold up their heads. Look for natural light, fill the frame with baby, and click!

Notice how the solid, soft-colored backgrounds in these two examples don't compete with the subject for attention. In fact, the pink and white fabrics act as reflectors, bouncing light onto the children to evenly illuminate their features. Both pictures were taken in natural light coming from an angle, which emphasizes textures in the photos (crinkles and folds on the pink sheet, nubby knitting on the white blanket).

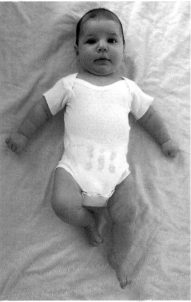

Rhonda Solomon

- Fabric texture will be most pronounced in raking light (when light shines almost parallel to the surface).
- A piece of white cardboard, placed just outside of the camera's range on the baby's shadowed side, can counteract shadows in a natural-light picture by reflecting light back, much as the light-colored blankets do in these examples.

These photos feature restful angels, but think about using overhead shots to convey scale, scene, and season. Picture baby on the changing table, on the grass, in a wagon or wheelbarrow, or a laundry basket or apple bushel.

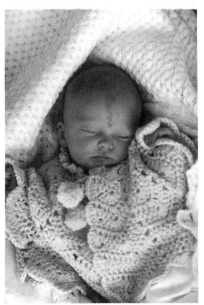

Joyce Hill Schweitzer

Big & Little

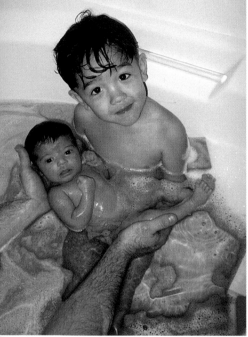

Kristina P. Caldwell

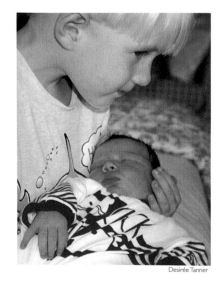

Desirée Tanner

I t's all about a sense of scale— capturing your unbelievably tiny newborn along with the pride of an older brother or sister. Such "big and little" photos begin to record the life-long relationship between siblings. The older brother in the top photo is oblivious to the fact that it's his dad's big arms that keep his little sister afloat in the tub. He thinks he's doing it!

Below, a much older boy really does cradle his sister's head with anxious awareness of his great responsibility. This image was aggressively cropped in the viewfinder, much to its advantage.

- Fill up the frame with the kids; resist the temptation to include background details that will distract the viewer.
- Crop tightly; in three-quarter length shots leave little, if any, space above the head.
- Balance such cropping; if you've come in close at the top, do the same for the bottom of the picture.
- Don't, however, crop limbs at the joints. This looks awkward.
- Position eyes in the upper third of the frame to make them the center of interest.

Fun tip: The gleaming white bathtub in the photo above acts as a light reflector to illuminate the figures from all around.

Baby expressions can be elusive. Goo-goos turn to grimaces. Smiles flash on and flash off. Then suddenly, baby's asleep. Now there's a picture of sweetness you can capture on film!

- Solid colors make the best backgrounds. The blue backpack below highlights the sleeping face.
- It's okay to add a whimsical touch (daisy, teddy bear) if there's time.

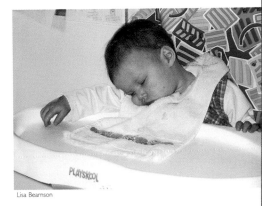

Lisa Bearnson

When Brecken fell asleep in her highchair, I could hardly stop laughing! But I regained composure enough to notice the white bib and tray were reflectors for her sweet face and little hands. I ran for my camera. When your baby falls asleep in a photogenic spot, go for it!

Rhonda Solomon

Strollers Are Where We Live

Gale A. Johnson-Peltier

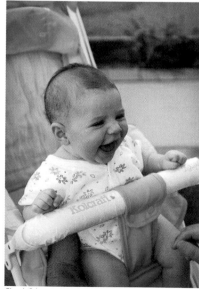

Rhonda Solomon

Babies see the world from strollers and baby carriers, and parents see a lot of these basic items of baby gear. Include them in your photos.

- To contrast with the busy patterns of modern strollers, dress baby in simple clothes and similar colors. Also, try using black-and-white film to simplify such scenes.
- Experiment with using different parts of the stroller as a frame.

Someday, when the stroller is long gone, these photos will be a reminder of your first forays into the wider world with your little one—and the equipment that helped you both.

h, the classic bathtub shot! Close-up, child's level, eyes open . . . what better occasion to discuss the red-eye effect?

Red eye happens in indoor photos taken with a flash. Pupils are wide because light is low, and the direct light of a bright flash bounces off the back of the eye. There are ways to avoid this.

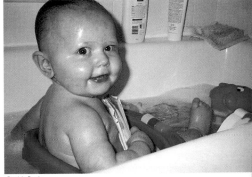

Patricia Bastia

- The anti-red-eye feature of some cameras emits pulses of light before flashing so pupils adjust.
- Hold an add-on flash as far away as possible.
- Position yourself so the flash points toward the ceiling or wall, not directly at baby's face.

Smart tip: Make sure to protect your camera from getting wet!

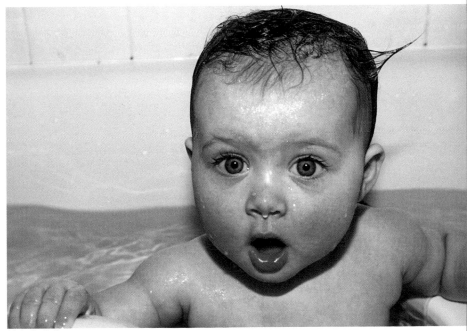

Heather Loughmiller

The Developmental Stages

Use photography to document the developmental stages you read about in baby books. For example, between four and six months of age, babies love imitating smiles (top). The airplane pose (middle) is a favorite for five-month-olds, but disappears when crawling skills emerge. Be sure to capture the gymnastic feats of little ones who scoot on all fours before crawling (bottom). Other photogenic milestones include:

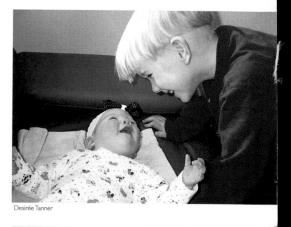

Desirée Tanner

- newborns' fencer's reflex (they extend an arm while curling the other toward their shoulder, as in a fencer's thrust)
- push-ups (about four months)
- rolling over (four to six months)
- first stands
- stages of sitting (with baby safely padded all around, of course)
- stages of crawling, from wobbler to speedster
- climbing, standing, and cruising (walking by holding on to furniture)
- walking

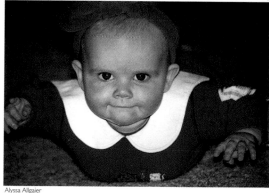

Alyssa Allgaier

Getting down to your child's level at some of these stages may mean putting your tummy on the carpet, as the person in the bottom photo demonstrates!

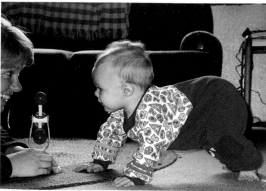

Angela S. Barrus

Ah, the classic bathtub shot! Close-up, child's level, eyes open . . . what better occasion to discuss the red-eye effect?

Red eye happens in indoor photos taken with a flash. Pupils are wide because light is low, and the direct light of a bright flash bounces off the back of the eye. There are ways to avoid this.

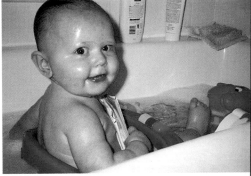

Patricia Bastia

- The anti-red-eye feature of some cameras emits pulses of light before flashing so pupils adjust.
- Hold an add-on flash as far away as possible.
- Position yourself so the flash points toward the ceiling or wall, not directly at baby's face.

Smart tip: Make sure to protect your camera from getting wet!

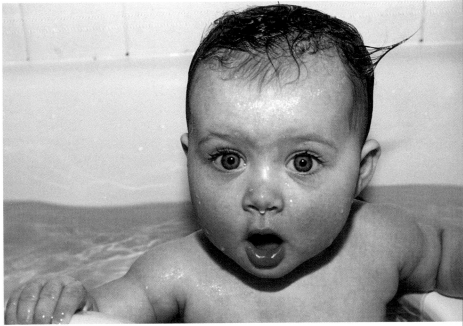

Heather Loughmiller

The Developmental Stages

Use photography to document the developmental stages you read about in baby books. For example, between four and six months of age, babies love imitating smiles (top). The airplane pose (middle) is a favorite for five-month-olds, but disappears when crawling skills emerge. Be sure to capture the gymnastic feats of little ones who scoot on all fours before crawling (bottom). Other photogenic milestones include:

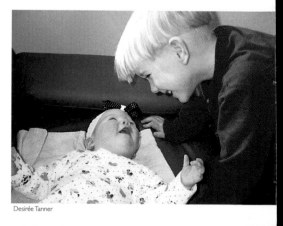

Desirée Tanner

- newborns' fencer's reflex (they extend an arm while curling the other toward their shoulder, as in a fencer's thrust)
- push-ups (about four months)
- rolling over (four to six months)
- first stands
- stages of sitting (with baby safely padded all around, of course)
- stages of crawling, from wobbler to speedster
- climbing, standing, and cruising (walking by holding on to furniture)
- walking

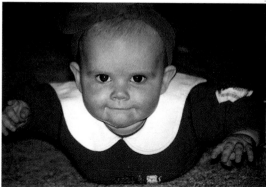

Alyssa Allgaier

Getting down to your child's level at some of these stages may mean putting your tummy on the carpet, as the person in the bottom photo demonstrates!

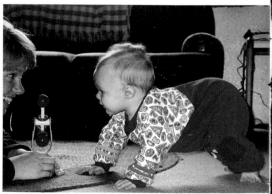

Angela S. Barrus

Shoot Upward

What happens when you shoot upward? Your child comes across confident. Even better, shooting upward in the outdoors often means you can place your child against the sky—a beautiful, bright blue backdrop unhampered by any clutter down on the ground. When shooting upward:

- position the subject to minimize squinty eyes and dark shadows
- try putting your camera on the ground below your child; don't bend over the camera, though, or you'll get in the shot

Fun variation: Have your children wear clothes and accessories (sunglasses, hats) in solid primary colors when planning blue-sky photos.

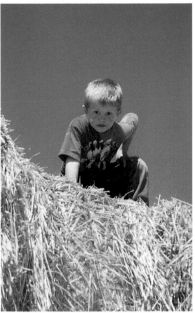

Lisa Bearnson

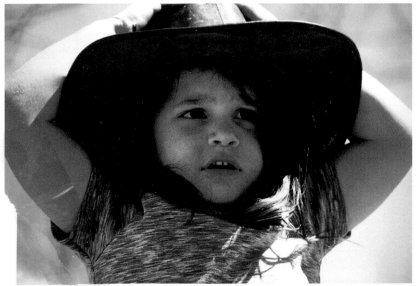

Rhonda Solomon

Shoot Downward

Patricia Bastia

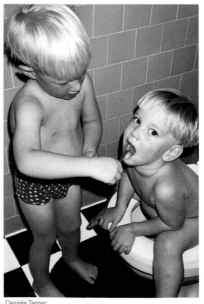

Desirée Tanner

Shooting downward foreshortens the subject. Your already small child appears even smaller. Shoot downward to stress vulnerability or innocence.

- Maintain a high camera position.
- Position the child's head in the top third of the photo. Because shooting downward reveals more of the top of the head, you may even want to crop out some of the crown when taking head shots so that the eyes still appear in the upper third of the frame.

Bathrooms make visually interesting impromptu photo studios. They're usually well lit and often incorporate highly reflective surfaces, such as tiled walls and ceramic bathtubs, which act as reflectors to brighten the subjects. From a compositional standpoint, bathrooms offer a number of practical props: tubs, toilets, sinks. As you frame your picture in the viewfinder, beware the graphic nature of all those tiles. Check that the floor or wall is acting as a supportive "frame within a frame." Make sure the strong lines don't distract the viewer or accidentally obscure part of your picture.

Fun variation: Experiment with the widest-angle lens setting your camera has and shoot a downard vertical shot. (On my camera, it's 8mm; a true wide-angle lens is 28m.)

Shoot from Behind

Photos don't always have to show faces to be revealing. Body language alone conveys a lot.

- Get down to your subjects' level. Kneel if you have to.
- To maintain one center of interest, make sure that multiple subjects make physical contact. The toddler at right pets the kitty, the brothers below touch at the shoulders.
- Frame the photo horizontally to capture the surroundings.
- Use color accents to lead the viewer's eye. In the bottom photo, red sneakers lead up to orange-berried bushes and off to the warm, russet house across the lake.

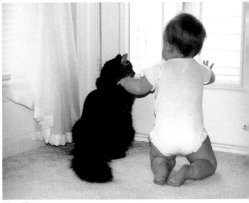
Alyssa Allgaier

Shooting from behind captures the world from *their* viewpoint. These photos linger in our affections because we can almost remember ourselves in these universal childhood scenes.

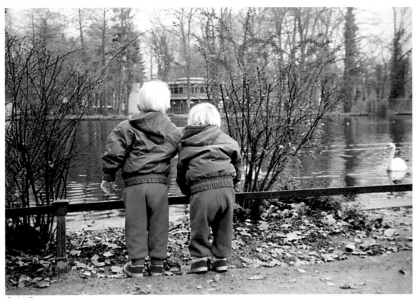
Desirée Tanner

Surround Their Faces

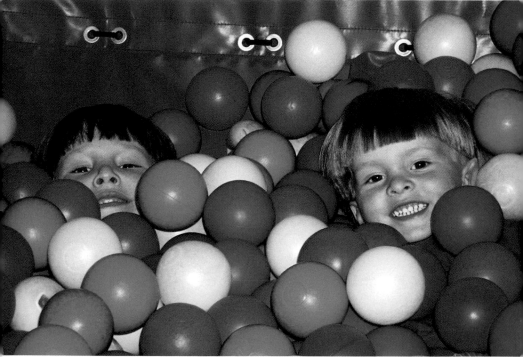

Brenée K. Williams

Diane L. Garding

Rubber balls, bubble baths, sandy beaches, autumn leaves. In a child's life, there are many opportunities for total immersion!

- Get in close. Crop tops if you have to. Use a zoom if you have one.
- Water and sand have reflective properties that brighten photos.

Fun tip: If you're very close and are shooting with a flash, move a finger in front of the bulb to keep light skin from getting washed out and dark skin from reflecting the flash.

Off with Their Shoes

B are feet tell the tales of carefree summer days, of freshly cut grass, of the first cold splash of water at the shore. And what child doesn't erupt in squeals of delight when his or her tootsies are tickled to the tune of "This Little Piggy Went to Market"? Barefoot photos evoke these classic childhood scenes. Consider other occasions when sweet feet can take center stage.

- Cleanliness counts; start with scrubbed feet.
- Use primary colors. Simple outfits, like the brightly striped T-shirt and shorts above, or the country-style denim overalls below, provide a nice contrast to muted backgrounds.
- Take pictures against a background that brings out the feet. Notice how the slate stone steps highlight the toddler's rosy beige toes, while the older boy's darker skin tone stands out against the off-white of the concrete.
- Blue jeans always look great next to bare skin.

Fun to note: The red geranium, baseball cap, collar trim, and red step lead your eye through the top photo without overpowering the subject. The color red always adds energy!

Carol A. Cousins

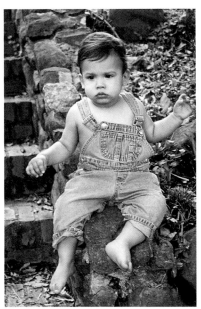

Sandra O. Aguirre

PORTRAITS: YOUR BEAUTIFUL CHILDREN

Use Your Furniture

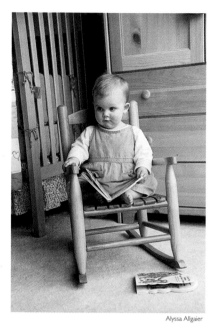

Alyssa Allgaier

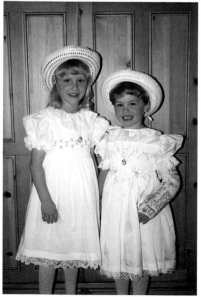

Diane L. Garding

Wood furniture can be a beautiful background for formal or informal portraits. A clean color element, such as white or blue, elsewhere in the photo strengthens the effect. Wood or upholstered furniture can:

- Support a baby. (Guard against the possibility of falls, though!)
- Form a solid backdrop. The golden armoire behind the two girls in white brings a textured element to the background without distracting from the duo. The ethereal quality of their lacy dresses plays off the natural wood grain.
- Emphasize the lines of perspective. In the top photo, the vertical lines of the crib and the horizontal lines of the dresser lead your eye straight to baby.
- Preserve the memory of an heirloom. Whether it's grandma's chair or a rec room beanbag, furniture can hold sentimental value that adds distinct character to a composition.

Make the most of your wooden backdrops by eliminating distraction around the edges of your photos.

Fun tip: Try moving a piece of furniture to the center of the room. This will reduce shadows on the wall from your flash and help avoid clutter.

Use the Mirror

Double trouble, or two for the price of one? Shooting into mirrors requires a few simple precautions, but the results are well worth the effort.

- Focus on the image in the mirror.
- If you can see yourself in the mirror, so can your camera.
- To exclude distracting details, compose the photo so that your subject dominates the frame.
- Refrain from using the flash when photographing mirrors and other reflective surfaces; it will be bounced back, causing a "hot spot"—a burst of light that will appear on the finished print.

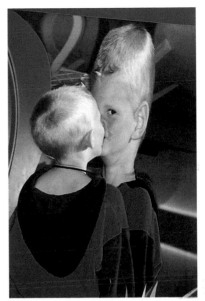

Desirée Tanner

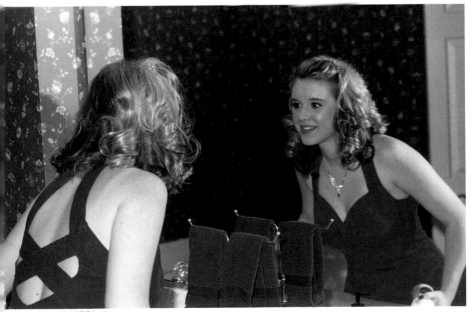

Joyce Hill Schweitzer

Shoot into a Sunset

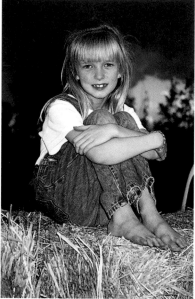

Kelli Ann Collins

Yes, you can! Capture the setting sun and the evocative beauty of the day's last light by following these few pointers.

- Look for high or wide-open areas so you can shoot until the sun sinks below the horizon.
- Use a flash so you don't create a silhouette, but don't get too close or you'll overexpose the faces.
- Let the sky take up about two-thirds of your frame so the camera will expose for it.
- Do not look directly at the sun.
- If you can see thin streaks through your viewfinder (flare), shade your lens or recompose your picture.

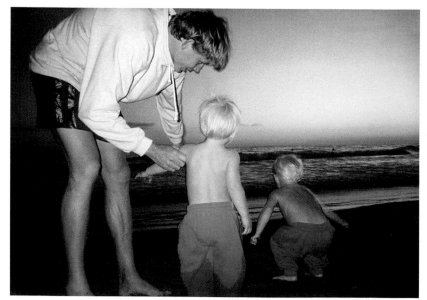

Desirée Tanner

Use Available Light

Stop! Don't switch on the flash. When faced with a challenging, limited-light situation, don't always fight it. Go with the flow, and give your photos a memorable glow. Known professionally as "low-key" images, photos that use a deliberately darker exposure can impart a mysterious atmosphere to your pictures. Exploit extreme contrast by using strong localized light that illuminates parts of the subject and leaves everything else in shadow. The aura cast by birthday cake candles, a single shaft of late-afternoon sun streaming through a small window, or a crackling campfire can all be effectively photographed.

- For sharp focus, get close. There's little depth of field (range of distances) in a low-light shot. Keep faces close to the light source without compromising safety.
- You have the best chance of making this kind of picture come out if fast film is in your camera. When planning, select the fastest speed of film your camera can handle (ISO 800 or 1000).

Fun tip: Faster films require less light to give a good exposure. Prints may appear coarser, but this effect actually contributes to the mood.

Fun variation: Conversely, use slow film when you've got too much light,

as you might have coming from a window on a very bright day. Try covering the window with a curtain of tulle or a similarly translucent fabric such as mesh or lace to soften the shadows. The combination of the glass panes and the opaque scrim will diffuse the harsh light, causing figures closest to the window seemingly to dissolve into the haze and focal points in the foreground to appear slightly overexposed.

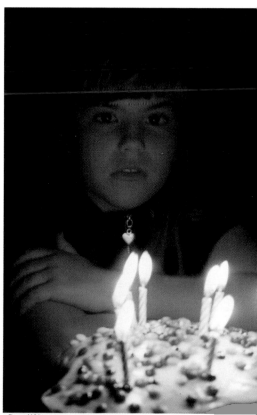

Shauna White

25

Sidelighting

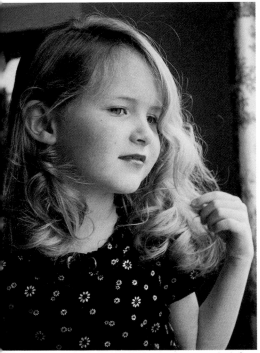

Angelyn Bryce

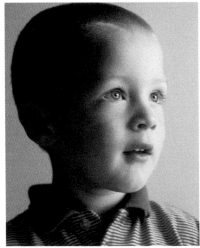

Deanna Lambson

Sit your child by a bright window in a darkened room. This will intensely expose the part of the face that receives direct light and cast the contours of the shaded side into contrasting shadow.

- Position your child near a window where you like the light. A north-facing window may filter soft, white, indirect light, while a window that looks out to the west can catch the last golden rays of a setting sun.
- Ideally, the light should hit your subject at an angle approximately 45 degrees to one side.
- In the photo at bottom, mom shot with ISO 200 film. In an automatic camera, this slow film reduces depth of field, blurring the background into a nondistracting haze. Pictures taken with faster film (ISO 400 or above) will have a more grainy quality but can keep background detail in focus if you need that for your photo.
- Sidelighting emphasizes texture, so try dressing your kids in plush velvet, rugged denim, or nubby knits.

Fun variation: Experiment with a simple reflector, like a big piece of white poster board, to create sidelighting. Just don't let the cardboard get into the photo.

Backlighting

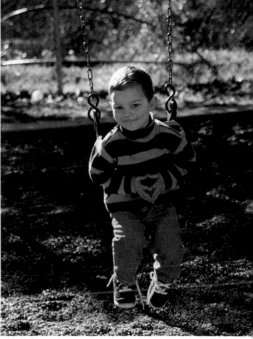
Joleen Hughes

very mother thinks her child is a little angel—at least most of the time! To prove it, photograph your cherub with the light behind him or her. The child's "halo" will appear in the finished prints and silence any doubters once and for all.

Backlighting occurs when you situate your subject between the camera and the sun, so it's easier to take this kind of picture early or late in the day because of the sun's lower angle. If used alone, however, backlighting may not sufficiently expose the front of the face. To keep your portrait from turning into a silhouette, try these tips.

- Shoot within about six feet of your child and use your fill flash. (If you stand any farther back, your flash won't bridge the gap, and, outdoors, you won't always be able to find flat surfaces, such as walls, to reflect back the light.)
- Use the backlight compensation button, if your camera is equipped with the option. This sets off a flash.
- Try using a piece of white poster board to bounce the sun back into the face. A white tablecloth on the grass will similarly act as a reflector.

At the pool, backlighting can make sprinkles of splashing water sparkle. Take care not to get your camera wet!

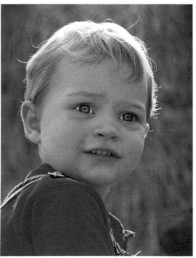
Joleen Hughes

PORTRAITS: YOUR BEAUTIFUL CHILDREN

27

Notice a Shadow

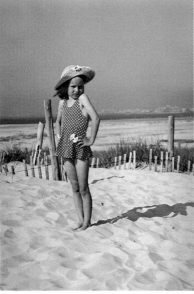

Angelyn Bryce

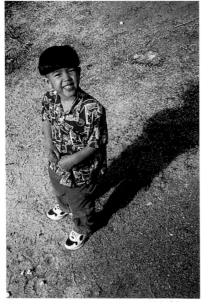

Kristina P. Caldwell

When we think of shadows, we think of the subtle shadings caused by light. When kids think of shadows, they think of their second selves—the friend who walks with them every now and then. Memorialize this childhood pal in your photos.

- Shadow length depends on the height of the sun. A setting sun casts longer shadows than a mid-day one.
- "Hard" lighting—light from a concentrated source, such as the sun in a clear sky, or, indoors, direct light from a small window—forms the best shadows. "Soft" lighting produces less-defined shadows.
- Surface also affects the quality of the shadow: you'll find a clearer outline on smooth pavement or sand than you will on grass.
- Try to get the whole shadow in the image. This may mean your main subject is off center, so see "The Off-Center Portrait," Tip #24.

To best photograph a shadow, the sun should be behind you. You can use the fill flash to compensate for any facial shadows. As a secondary source of light, the flash may even momentarily intensify the shadow.

Fun variation: Try shooting a shadow shot from behind. You won't need the flash to light a face.

A Photo in the Car

A re we there yet?" For many families, the car becomes a second home, a mini-restaurant, a last-minute classroom, a mobile hotel. Use your car as a setting for portraits.

- Windows are the most distracting element of in-car photos. Crop them out. This mom cropped close *and* used the back seat as a strong, solid background.
- If you're shooting from outside the car, a window can work as a "frame within a frame" when the kids peek out. Other graphic elements—an elaborate hood ornament, the curved casing of the spare tires—can add color and help date the photo in future years after automobile styles change.

The youngsters in this photo had been dueling raucously during this car ride, so mom was surprised to find them so sweetly asleep at journey's end!

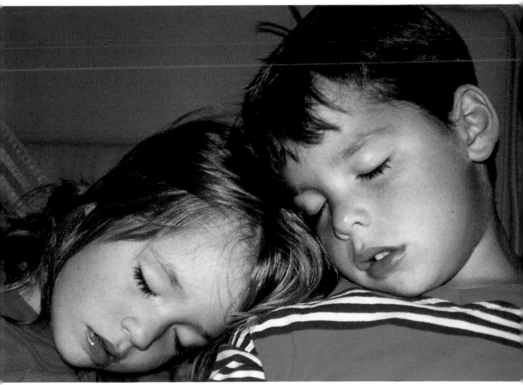

Kelly C. Slone

29

The Profile Portrait

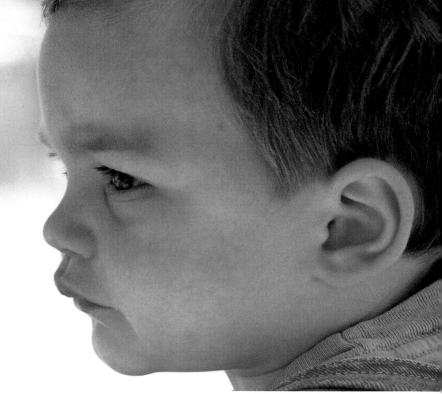

Joleen Hughes

A portrait in profile imparts a certain thoughtfulness and maturity to even the tiniest tots.

- Adjust your position to avoid distracting background elements.
- Use the telephoto setting to get in close if you have a zoom feature.
- For a horizontal close-up, it's okay to crop in tightly, particularly at the top of the head, but be sure to leave a little room below the chin.

Don't cut the ear down the middle: either include it or crop it out completely.

- Allow some space in front of your child's face so that he or she has somewhere to look.
- Shoot at eye level for a true-to-life perspective.

"Camera shake" can be a worry when using the telephoto setting. Try resting your camera on a wall or fence.

The Off-Center Portrait

A basic rule of photographic composition is the "rule of thirds." By positioning your subject off center, you introduce an energy that centered images don't have.

Imagine your frame as a grid divided into thirds—three equal horizontal segments and three equal vertical segments resulting in nine squares, just like a tic-tac-toe board. You get four off-center points, the four corners of the center square.

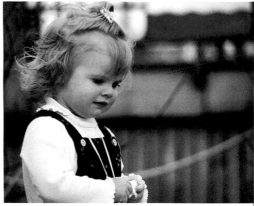

Alyssa Allgaier

- In the photo above, the girl's head is positioned approximately on the top left intersection point.
- In the photo below, Kade, who's taller than Collin, is positioned on the top right intersection point.

If you have an autofocus camera, remember to prefocus on your subject in the center of the frame before re-adjusting your composition and clicking the button.

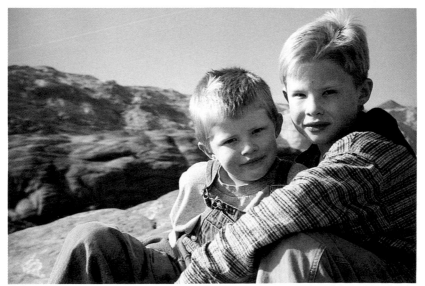

Lisa Bearnson

PORTRAITS: YOUR BEAUTIFUL CHILDREN

31

Cuddle Shots

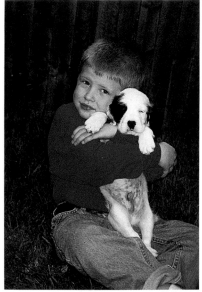

Lisa Bearnson

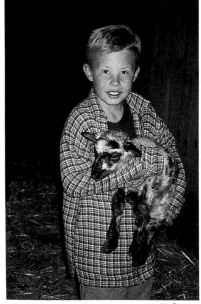

Lisa Bearnson

uddle shots. What could be cuter? All the fuzzy, feathered residents of the local petting zoo bring out the tender side of your child. You're almost guaranteed a natural facial expression from the human in your photo, so pay special attention to the animal in question. Here are some hints.

- Make sure someone present knows the creature's personality before picking up an animal at a petting zoo or children's farm. Even tame animals can bite.
- Avoid the flash to avoid panic.
- Bring extra film; animals don't always understand English.
- Multiple subjects should be touching. In most cases, your child will be hugging the small creature.
- The child's eyes should be in the upper third of the frame. Small pets are lightweight enough to be lifted up for a cheek-to-cheek shot.

I took both pictures near eye level so they'd convey the affinity between Collin, Kade, and the animals in the photos. To get a different mood, try a few shots from above, looking down at your beloved offspring who, arms uplifted, offers you a new, four-legged addition to the family!

Fun tip: Don't forget other cuddables: stuffed animals, security blankets, baby brothers and sisters.

Tummy Shots

rue, these four girls are all belly-down, but there's more going on in these two-person portraits that helps convey a sense of camaraderie.

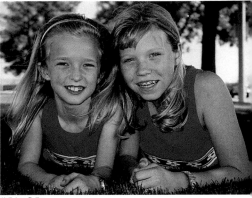

Kelli Ann Collins

- Eyes are at about the same level and in the upper third of the frame.
- Each pair is touching, shoulder to elbow, keeping the center of interest unified.
- Repeated elements—the same pink tank tops or Groucho Marx glasses—also unify the composition.
- The subjects fill the frame.

By the way, to take these tummy shots at eye level, the photographer has to get down on her stomach, too!

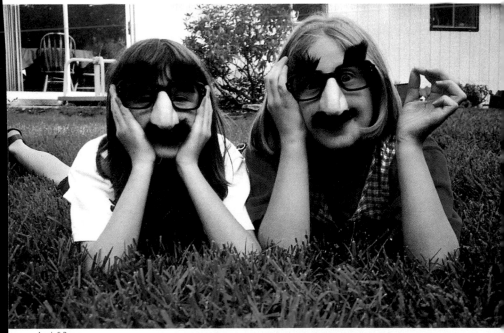

Angela S. Barrus

33

Double-Decker & Topsy-Turvy

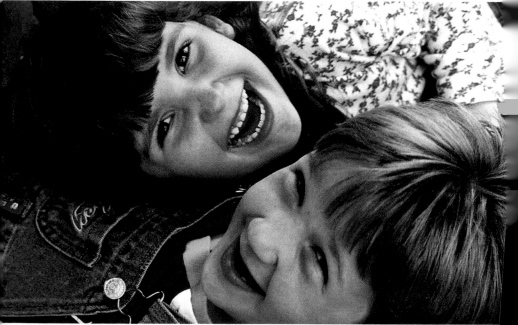

Nancy Elletson

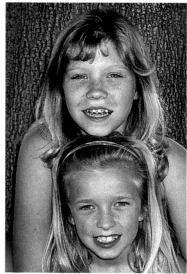

Kelli Ann Collins

Symmetry is the charm of these two-person portraits.

- In the top example, the repeated shape of laughing mouths and smiling eyes unifies the image.
- At left, the two heads align, one on top of the other, totem-pole style. The bottom girl's headband seems to reflect her sister's braces! Seen up close, the tree trunk makes an abstract natural backdrop.
- Both pictures are tightly cropped to good effect.
- Remember to give each person his or her own head space.

Hide-and-Seek behind the Trees

Head out for a walk and play a simple game of hide-and-seek to get some natural facial expressions for outdoor portraits. Trees are very cooperative—for one thing, they never get tired of standing still—and your child won't have a hard time cooperating with you if you make a game of your photo session. Consider the ideas these three pictures offer:

- Right: Goldilocks emerges from the woods, her smallness emphasized by the higher camera position.
- Below left: A V-shaped frame.
- Below right: The teen's tweedy cap echoes the leaf-flecked woods behind her, but her red sweater adds color to a neutral landscape.

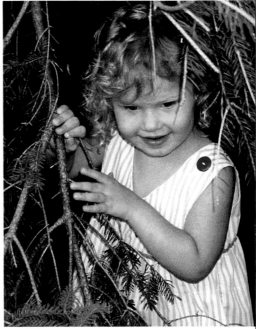
Annette B. Mortensen

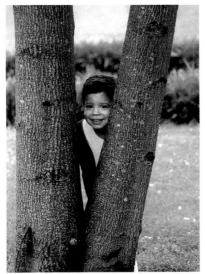
Sandra O. Aguirre

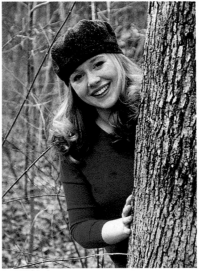
Joyce Hill Schweitzer

PORTRAITS: YOUR BEAUTIFUL CHILDREN

35

Pssst! Hey, moms, over here. I've got a hint for you. To properly populate your pictures, don't forget the decorations. Use props because they're fun, they're funny, they're worth remembering, but most of all, because they're *there*.

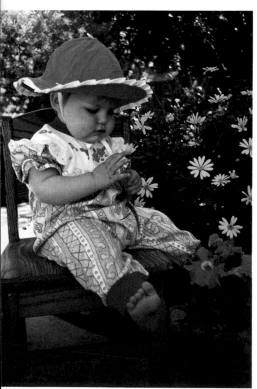

Lanae B. Johnson

Childhood is chock full of stuff: plush animals, dress-up dolls, action figures. Trikes and bikes. Board games. Balls and bats, helmets and hockey sticks. All those school supplies: textbooks, notebooks, storybooks. Then there are the clothes: cute feetie pajamas, costumes for the school play, even an old prom dress. But, be they favorite teddy bears or pairs of baby booties, sooner or later, your children will outgrow the things of their youth. Photographing these beloved objects helps to preserve them in the family's memory.

More practically speaking, special things can contribute to the composition of your pictures by adding color, energy, and visual interest. They can provide a "frame within a frame." And they can give your pictures holiday atmosphere or remind you of a family vacation.

So glance around the house and garden at all the clutter of your every-

With their vivid colors and appealing shapes, flowers make fabulous— and fascinating—props.

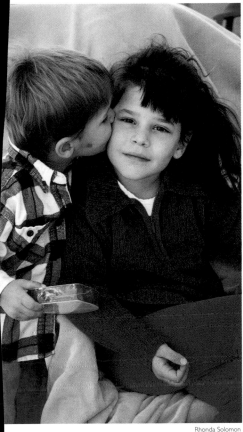

Rhonda Solomon

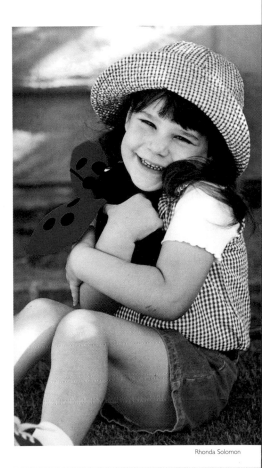

Rhonda Solomon

day life. Look for eye-catching, smile-inducing items. Then grab 'em and add 'em to your photos. And don't just stack objects in a tidy still-life. Let your kids interact with them—after all, when it comes to playing, they're your resident experts.

If you're really feeling adventurous, test out the possibilities of what photo experts call "false attachment." This is usually a mistake, as when a tree branch appears to grow out of Dad's head. But when you use props to purposefully connect things that aren't really connected, the results can be

A red valentine, a cherished toy, a face-framing hat in eye-catching checks. All attract attention.

hilarious. Imagine getting your son to squat down to chin level at the dinner table so that you can serve his head on a plate, or giving your daughter a new hairdo by standing her in front of a fringed lampshade. Think about your props above and beyond their intended uses, and have fun. The happiness will show in the photos.

37

Look for a Frame

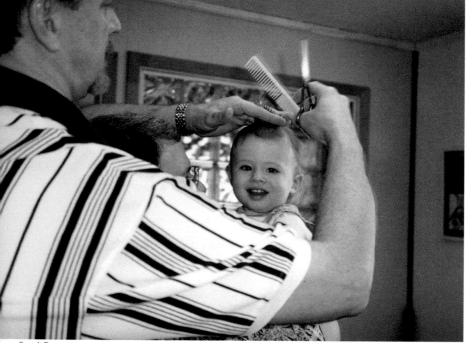

Gwen A. Grace

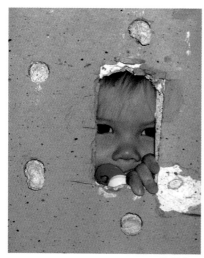

Desirée Tanner

The first frame is the one outlined by your viewfinder. If you can find a second one it will reinforce the first, centering attention on your subject and strengthening the impact of your photo. The trick is to train your eye to spot frames in:

- entrances
- archways
- windows
- mirrors

Or create them yourself from, for example, long hair, arms and hands (above), jacket hoods, hats, and scarves.

Kids are serious about having fun. It's their job. So catch them at work.

- Rather than posing your child alongside his favorite plaything, wait for him to get engrossed in pulling, pushing, washing, building, or painting.
- Get down to his level and photograph him in the act.
- A zoom feature lets you change the size of your subject without having to change camera position.

Body language speaks volumes. In the photo at right, firmly planted feet

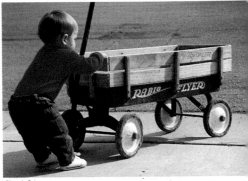

Rhonda Solomon

and the bend of the back let everybody know this is one determined little guy. Spots of color throughout (red above, blue below) unify both pictures.

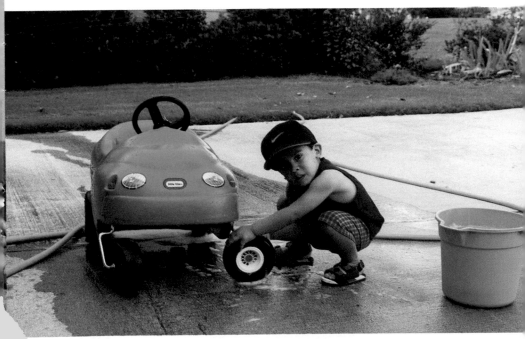

Sandra O. Aguirre

Snap the Silly Times

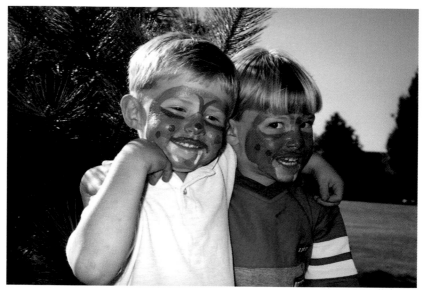

Lisa Bearnson

Sometimes special things are silly things. Call on your best portrait-taking skills to capture the trappings that put a twinkle in kids' eyes: face paints, costumes, even stickers. At Collin's birthday party, he and his cousin Christopher insisted they have their faces painted exactly alike! The two were inseparable, as well as identical. Bear in mind the veteran mom photographer's rule for silly shots:

■ Shoot now, discipline later!

You'll have many occasions to call the above rule into action! Include storytelling details, such as the sticker book at left, when possible.

Fun variation: Experiment with your camera to make silly shots even sillier. Use the widest-angle lens of your zoom (the lowest number), get up close, and shoot from above or below to distort faces for a funhouse-mirror effect.

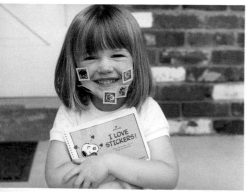

Joyce Hill Schweitzer

Re-create at home some of the special techniques professional photographers use in their studios.

Alyssa Allgaier

- To create a soft-focus look, loosely drape plastic wrap across the lens of your camera (right). Make sure the wrap has no wrinkles.
- If you have a lens that takes filters, you can also achieve this look by smearing a little petroleum jelly around the edges of an inexpensive clear (UV) filter. But don't try this directly on the lens—you'll permanently damage your camera.
- Paint your own backdrop. In the photo below, mom and dad painted the backdrop and let the children create their own Mexican- style costumes using hats, clothes, and props.

Study professional photos and pictures in advertisments and use these ideas to create similar looks in your home or backyard.

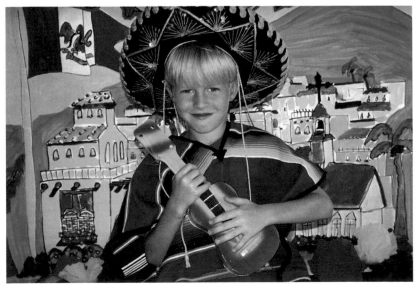
Angelyn Bryce

Yummy Props

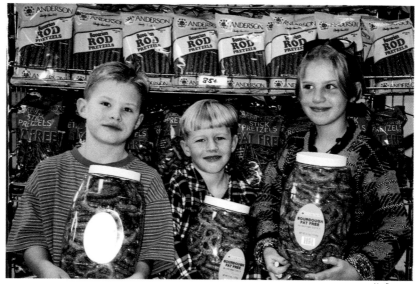

Lisa Bearnson

L ove your lollipops. Scream for ice cream. Embrace your inner eggplant. Food props can be strong reminders of vacation trips, weekend outings, or roadside stops. They nourish your photos in the following ways:

Lanae B. Johnson

- They're colorful. When we went to a pretzel factory in Pennsylvania Dutch Country, I was struck by the great colors and attention-grabbing design of the pretzel packages. In the picture of Kade and his friends above, the oval yellow labels act as bull's eyes, one calling attention to each child.
- They make great backdrops. As in the pretzel display above, a wall of boxes, bottles, or locally produced delicacies can make a great background texture for your photo.

And don't forget to play with your food. Wear hot-dog smiles, a banana-bunch wig, oranges for eyeballs. But save these monkeyshines for home!

Easter Egg Ideas

After Peter Cottontail has made his rounds, follow your children down the bunny trail as they search out their Easter bounty. Egg-centric methods of getting eggs into your Easter photos include:

- **Ambush:** If you spot an egg before any of the children, position yourself strategically, and wait. Catch the look of surprise when someone makes a discovery. If you have a telephoto lens, use it so you don't give away the location.
- **Assistance:** Some family members may need more help. When you're very little, finding a brightly colored egg in your own lap is

Deanna Lambson

surprise enough! For a shot like the one above, mom needs to be tummy-to-grass.

- **Abundance:** It's fun to look at all the colors after the eggs are found.

Lanae B. Johnson

PROPS: SPECIAL THINGS IN YOUR PHOTOS

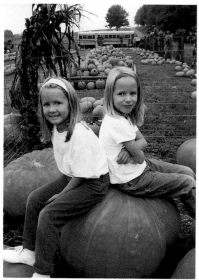

Angelyn Bryce

Pumpkin, pumpkin, burning bright, make all photos turn out right!" With their flaming orange color, textured ridges, and substantial sizes, pumpkins can do no wrong. Is it any wonder they inspire odes in their honor?

When photographing these seasonal orange props:

- Clothing counts! Encourage your children to wear colors that will look good with orange. Simple clothes in solid colors are best. In the photos on this page, clean white T-shirts with blue and purple bottoms look

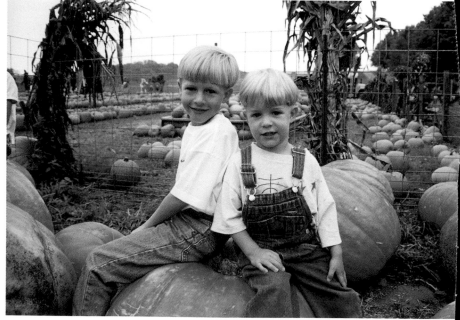

Angelyn Bryce

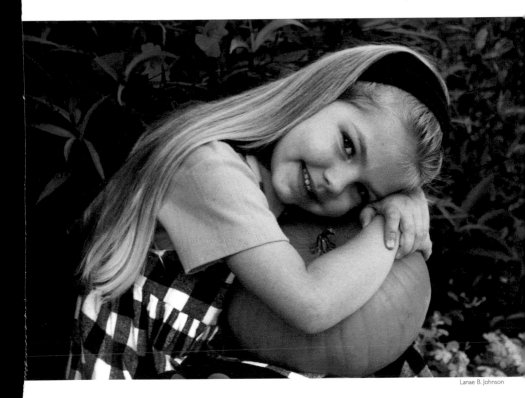

Lanae B. Johnson

great with the orange backgrounds.

- Find a single pumpkin to pose with among the many in the field. A very large one that begs for a cuddle will look particularly attractive.

- Watch out for glare. In the bottom right photo, Brecken found the pumpkin she wanted, but I couldn't get a good photo because the blazing sun made her squint. So I asked a friend to stand in the sunlight so she'd be in her shadow. It worked great! Brecken relaxed, the pumpkin relaxed, and I love the result.

- If your camera has the option, set your exposure override to -½ or -1 to deepen the colors in the print.

Lisa Bearnson

| # In the Land of Grown-Ups

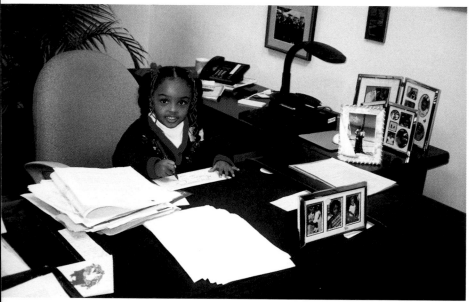

Gale A. Johnson-Peltier

I n the extra-large land of grown-ups, children seem smaller than they already are. Shoot from above and they'll shrink a bit more.

Kids love the chance to sit at your

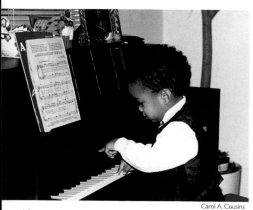

Carol A. Cousins

desk—sometimes while you're not looking. When you walk in on such a scene, stop a moment to watch them pretending to do the things you do.

- Shoot first, discipline later.
- Take one shot from a distance or use the wide-angle setting to capture the entire scene.
- If you have time, scan the image and think of the viewer's perspective. In the top photo, notice how all the pictures decorating the desk are turned outward. Normally, they'd face the other way, but a sharp eye realized that the backs of the frames would detract from the composition.

The First Day of School

ow can you tell it's the first day of school? The clean, bright, slightly uncomfortable backpacks. Oh yes, and those looks of anticipation!

Allow a little extra time in the morning for a little photo session including all the details: the brown-bag lunch, the clothes laid out on the bed. Outdoor pictures can be a challenge because there's a lot of glare in the early morning sun, especially in late summer. Find a shaded spot: I stood Collin under a tree. In the photograph at right, the children were protected by a stone wall, but the sun still came up over their left shoulders. Look for other special lighting effects—just make sure the kids aren't squinting in the early morning sun!

- If you have a zoom lens, you can shoot the different portraits from the same position by adjusting the framing.
- With a fixed lens, reposition yourself for each new shot.

Lisa Bearnson

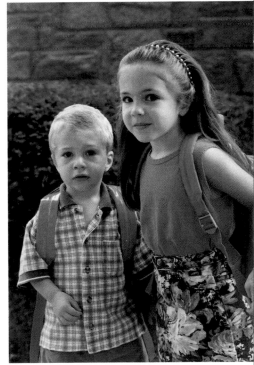

Nancy Freeman

47

Pool Gear

Day-Glo colors, chlorinated water, bright summer sun. Pool gear pops! All the ingredients are in place for a sizzling photo opportunity.

- Make sure to protect your camera. Put it in its protective housing or at least wrap it in a thin, transparent plastic bag with a hole cut out for the lens. Better yet, use a waterproof unit.

- Strong midday sun can wash out subtle shades but intensify strong colors. Counter harsh facial shadows with the flash, and use a slow film, such as ISO 100.
- Early morning and late afternoon sun deepen the blue of pool water in photos.
- Shade your lens to prevent flare by cupping your hand around the lens.

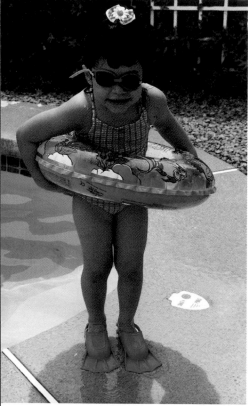

Rhonda Solomon

Carol A. Cousins

Pillows & Coverlets

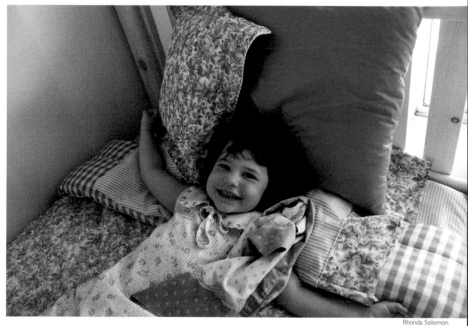

Rhonda Solomon

People always photograph new-borns in their cribs, but why stop there? Lots of children cherish their beds as their own special territory.

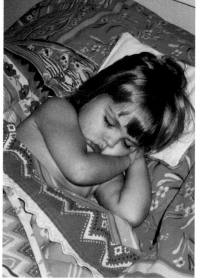

- Get in close and fill the frame with decorative sheet patterns.
- If you have bunk beds, use the framework of the two stacked beds and their connecting ladder as interesting frames. When photographing a child on the lower bunk, make sure to use the flash to illuminate any shadows.
- To catch a pillow fight in action, pre-focus and use fast film, such as ISO 400, to freeze motion.

Lanae B. Johnson

PROPS: SPECIAL THINGS IN YOUR PHOTOS

Say It with Flowers

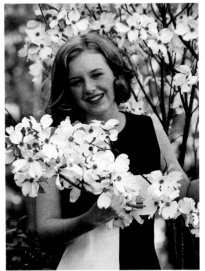

Joyce Hill Schweitzer

Nature offers us the most perfect prop: flowers. Plan a springtime visit to a local botanical garden, arboretum, or other public garden for a stroll and a photo session. These examples use flowers as props in all sorts of styles:

- **Classic:** By standing in front of a flowering bush and gently bringing one branch down in front of her, the young lady at left is beautifully framed by dogwood blossoms.
- **Casual:** In denim overalls suitable for gardening, the girl below stops to smell the daisies.

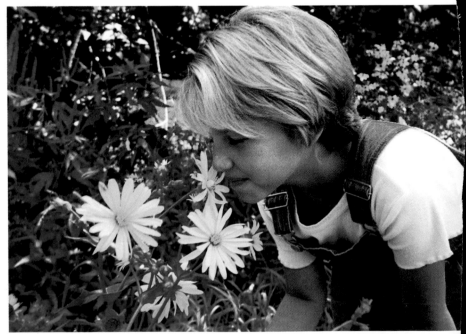

Annette B. Mortensen

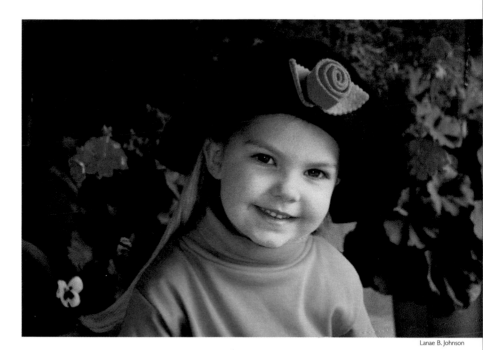

Lanae B. Johnson

Horizontal framing captures lots of details, and the two central points of interest—the girl and the blossoms in the foreground—connect at the center.

- **Unconventional:** The turquoise turtleneck and matching leaves on the girl's hat (above) help to frame the face of this sidelit little one, while spots of magenta, in both the geranium blossoms and the hat brim's rosebud, unify the picture.

- **Ceremonial:** Crimson buds brighten the stark white of this girl's outfit, and the sea of bright annuals behind her fill the frame with rainbow hues. The downward path of the stone steps, flanked by the flower beds, leads the eye right to the subject.

Carol A. Cousins

51

A Little Bit of Red

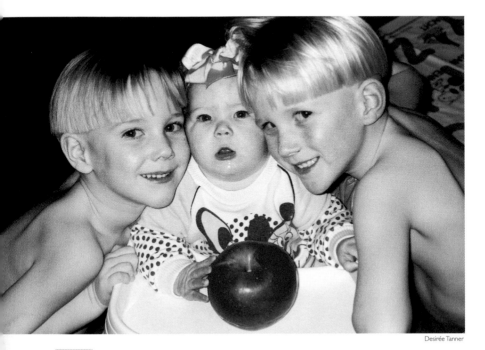

Desirée Tanner

An apple for the teacher, a tiny M&M, a long-stemmed rose, tiny berries on a holly branch. A touch of red can be the difference between an ordinary photo and one that holds your attention, providing a bright focal point without overwhelming the picture.

Look for a little bit of red in:

- cherries, strawberries, tomatoes, peppers, sliced watermelon
- roses, carnations
- autumn leaves
- hats, gloves, scarves, buttons
- canvas sneakers, casual shoes
- stop signs, fire hydrants
- tricycles, bicycles
- toy wagons, sled runners
- plastic snow shovels and beach buckets

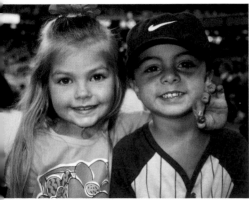

Lanae B. Johnson

A Whole Lot of Yellow

Warm, wonderful yellow cheers up even the cloudiest day. That's why it's the official color of rain slickers and school buses, smiley-face stickers, city taxis, musical submarines, and the winding brick road to Oz.

As bumblebees know, yellow jumps out against black (and deep blues, greens, and browns). A classic yellow coat—whether it's part of a fireman's costume or rain gear—makes an outfit worth a photograph. Yellow invigorates a neutral background.

- Photograph yellow against a plain, dark background.
- Emphasize contrast by limiting the number of colors in your picture to the dominant yellow and then to one or two other hues.

Look for a whole lot of yellow in:

- supermarket racks of grapefruits, lemons, and bananas
- fields of wheat, goldenrods, daffodils, and rows of forsythia
- amusement parks

Joleen Hughes

Rhonda Solomon

Stripes, Checks & Polka Dots

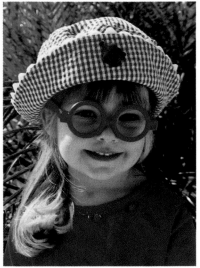

Lanae B. Johnson

Clothes can make the photo! Stripes, checks, and polka dots electrify a scene. Clear, bold patterns like these are rare in children's clothing, so it's worthwhile watching for them when shopping. Train your eye to spot graphic patterns in potential props, such as in the boy's popcorn box below or the girl's hat at left.

When using patterns, don't overload the circuits. Conserve energy with one of these strategies:

■ Let the main accents pick up the color of the pattern. The three examples on this page feature red

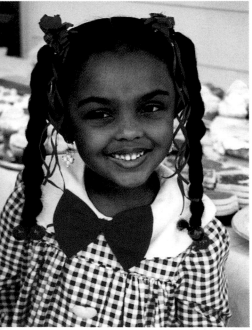

Gale A. Johnson-Peltier

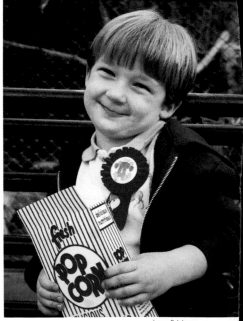

Lanae B. Johnson

Desirée Tanner

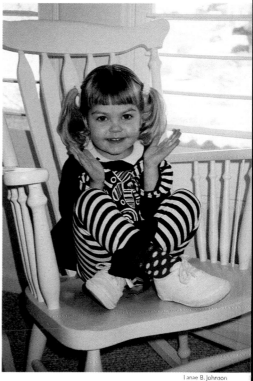

Lanae B. Johnson

patterns—red gingham hat, red
gingham dress, red striped box.
The main accents are red—glasses,
hair barrettes, award ribbon.
Harmony is intact!

- Use a single color to unify differ-
 ent designs. In the photo above,
 the twins wear identical striped
 shirts, while their sister's jumper
 features a pattern, but the combi-
 nation still works because all the
 items are in black-and-white.
- Set off bold props with solid back-
 grounds. The popcorn box looks
 great because the dark sweater
 doesn't fight it.
- Fill the frame. These outfits have
 all the excitement you need!

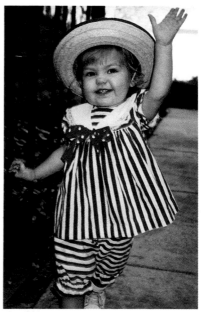

Lanae B. Johnson

PROPS: SPECIAL THINGS IN YOUR PHOTOS

55

A DAY IN THE LIFE

CANDID PHOTOS

OF YOUR CHILD

CANDID PHOTOS

Start photographing your children now. Don't wait until you get a better camera, or grandma comes for a visit, or baby takes his first steps. If your children are comfortable in front of the camera from an early age, you'll have a better chance of getting natural-looking shots as they get older. Their lack of self-consciousness, combined with a casual discretion on your part, will result in some wonderfully spontaneous images.

In candid shots, kids are caught off guard. They may not even realize you've taken their picture. Compared to standard posed photos, in which everyone stares straight at the camera and responds on command to "Say cheese!" candids convey the mood of the moment by capturing natural body language. You don't need to see the eyes of the young artist on the next page to feel how focused she is on finishing her drawing—it's there in the jut of her lower lip, the tight grip on the crayon.

Automatic cameras make it more likely that your candid shots will be clear, but beware the flash, which will expose more than your film. If your

Joleen Hughes

Lots of spontaneous splashing takes place in the tub! Just protect your camera from getting wet.

camera has a zoom option, and you can spare a second to make the switch, try the telephoto setting. It will enable you to get in close without giving away your position.

If the essence of candid photography is spontaneity, how do you prepare ahead of time? First, adhere to these three rules of thumb:

1. Keep your camera handy. Don't pack it away on a shelf in a closet. Leave it in a safe place in the kitchen, the hub of most family activity.
2. Keep your camera loaded: When inspiration strikes, you don't want to find yourself without film. Always load and unload film in subdued light. If you're stuck in the sun, use your body to shade the camera. Don't open the unit's back until you've double-checked that the film has been rewound. If you have to do so manually on your camera (as with most single lens reflex cameras) make sure that you set the applicable ISO number on your camera. Store extra rolls of film in the fridge.
3. Keep your batteries fresh. Buy them on sale, in bulk.

Next, check the calendar. Will your child be opening a surprise present any time soon? Hearing a good joke? Tasting a new recipe? Watching a sports showdown? Think of the types of events where children have been known to act a tad loco: snowball

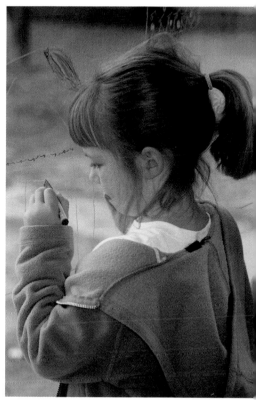

Joleen Hughes

Great candids capture genuine interest. Children can get so engrossed in their activities, they forget you're there, waiting, with camera in hand.

fights, sleepover parties, duck-duck-goose. Be ringside, camera-ready.

Then practice! Practice, practice, practice, so that photography becomes second nature. The best images are rarely those that have been painstakingly composed. Instead, they're the ones that seem to magically capture all the poetry of a unique moment in time.

Keep on Shooting

Joyce Hill Schweitzer

Joyce Hill Schweitzer

Joyce Hill Schweitzer

Progressives," as photographers call them, are a storytelling series of pictures. If you spot your child in action, grab the camera! Most recent point-and-shoots have features that make it easy to snap a series.

- motor drive—so you don't have to manually advance the film between shots
- autofocus—so you don't have to refocus for each new shot

Just the composition is up to you! Crop out unrelated elements, use the zoom if you have one, and try not to worry about wasted film. The keepers will be worth the shots you toss.

Smart tip: If your camera has a red-eye protector, it will stall your camera before it snaps your photo. Turn it off for this type of shot.

Joyce Hill Schweitzer

apture the body language of fascination along with the thing that is so fascinating as you document your child's everyday life. To get that mixture of absorption and awe that characterizes the constant learning of childhood:

- don't ask them to say cheese
- try a profile shot
- show interaction with the object of interest (or at least a key portion of it, in case it just happens to be an elephant!)

Children learn with their whole bodies, so be sure to portray them reaching, touching, sniffing, or listening as well as looking.

Nancy Freeman

Joyce Hill Schweitzer

CANDID PHOTOS: A DAY IN THE LIFE OF YOUR CHILD

59

Document a Pastime

Deanna Lambson

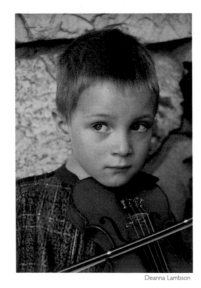

Deanna Lambson

Document the hours your child spends each week engaged in a favorite activity. Create a portfolio depicting the many aspects of the hobby.

- Shoot candid portraits of the child involved in the pastime in several sizes and from several angles.
- Extreme close-ups can highlight the specific skills required. Think about the details of the activities: a violinist holding the instrument, a rider notching the harness of a horse.
- Take still lifes of all the related paraphernalia. In the case of a violinist, include case, bow, and sheet music.

Shot surreptitiously, candids of children interacting will reveal kids' rules of behavior—their social order in the absence of adults.

- Shoot at eye level to participate in their world.
- Prefocus with one of your subjects in the center of your viewfinder; then quickly reframe your composition, but don't click until there's a moment of contact.
- Use the telephoto setting of the zoom lens to get in close and to cut down on depth of field.
- Turn off your red-eye protector for more spontaneity. Use flash only at risk of being exposed!

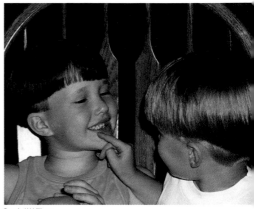

Brenée K. Williams

If you think raising the camera might unmask your intentions, snap a few photos without looking through the viewfinder. Shoot from the hip!

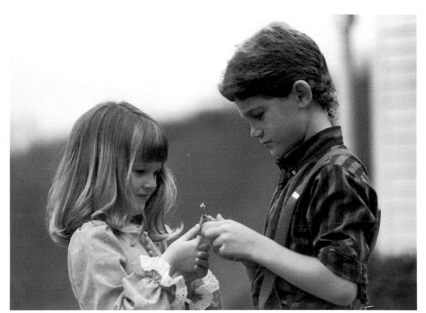

Joyce Hill Schweitzer

61

Spontaneous Outbursts

If the outburst is spontaneous, how can you plan in advance to photograph it? When I wanted to photograph the kids playing with their cousin's new puppies, I noticed everyone was wearing white T-shirts. I made them all change into bright tops so the white puppies would show up! This didn't reduce the spontaneity of my pictures—it just made them better. The golden rules of candids include:

- Be prepared! Keep your camera on hand, loaded with film and fresh batteries.
- Think ahead about what people might be wearing.
- Don't be afraid to get close to the action.
- Keep on shooting.

If you want to get close to the action without getting knocked over by a puppy or hit by a snowball, use your zoom. If you don't have a zoom, don't be afraid to nose in. The momentum of kids' play is sometimes strong enough that they won't even notice you. These can be some of the most photogenic moments for a shot.

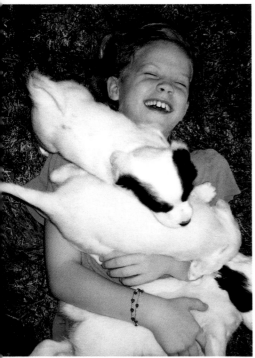

Lisa Bearnson

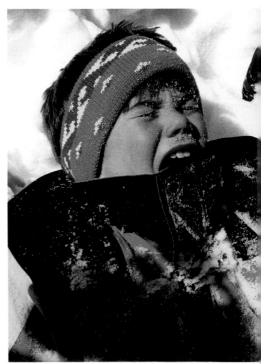

Shauna White

Taking It Seriously

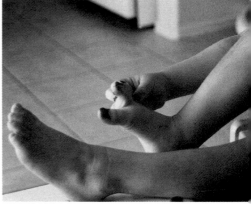

Rhonda Solomon · Rhonda Solomon

Your children may not notice you're taking a photo when they're concentrating hard. Capture the fixed stare, the furrowed brow, the clenched jaw of determination. Try setting the camera on a tabletop and shoot from there.

If you have a telephoto zoom setting on your camera, this is a good time to try it. Bear in mind:

- The longer focal length of the telephoto setting increases the size of your subject within the frame.
- The telephoto enlargement also simplifies the background by reducing the depth of field and putting the background out of focus.

Fun tip: If you use a regular lens setting instead of telephoto zoom and compensate by physically getting closer to your subjects so that they appear large within the frame, the resulting picture will include much more of the background. Compensate by cropping close in the viewfinder, as shown in the bottom picture.

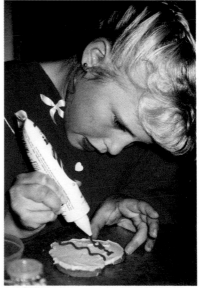

Lanae B. Johnson

CANDID PHOTOS: A DAY IN THE LIFE OF YOUR CHILD

63

Telling Details

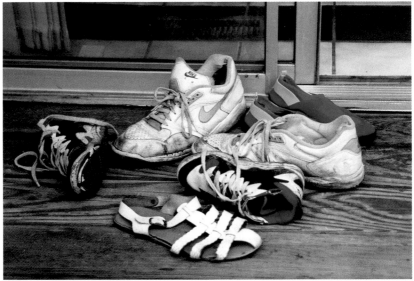

Deanna Lambson

Part of documenting your child's life in photos is telling a story with the pictures. Look for details in your everyday life that help punctuate the story and mark the passage of time.

These photos of shoes have their own stories, from "ready to go" to "all tired out." They are perfect detail shots supporting much longer stories. When shooting still-lifes:

- Notice artful but accidental arrangements.
- Alternately, artfully arrange the objects, positioning them randomly by characteristics, such as height and color.
- Look for a plain background, or one with some neutral texture, such as wood or pavement.

Fun tip: If your still-life composition features heirlooms and you're taking the photo indoors, try diffusing the light by veiling the flash with a thin skin of tissue paper.

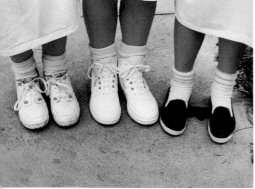

Joyce Hill Schweitzer

fter the story's over, don't forget to say good night. Lullaby babies make dream candid photos.

Everyone takes baby pictures over the top of the crib. Try getting down to the child's level and shooting through the crib's bars. In this photo, the crib's golden wood came out looking beautiful. To take a picture through the bars of a crib:

- The closer you get, the more out of focus the bars will appear in the print. This is good. It makes them less intrusive.
- If there's enough light in the room, turn off the automatic flash. The burst may be an unintentional alarm clock.
- If you need some light but think the full flash may be too much, try covering part of the flash with your finger, or flicker your finger in front of the flash while you're taking the shot. This trick will reduce some of the harsh effect.

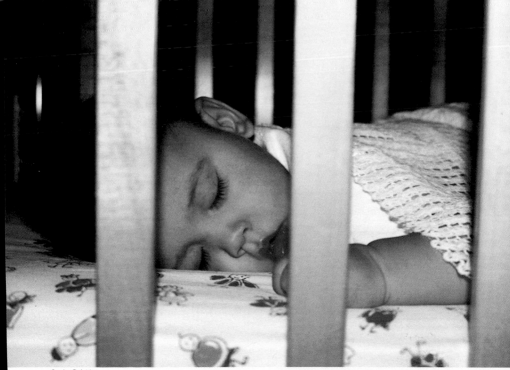

Sandra O. Aguirre

utumn leaves, winter snow, spring meadows, summer beaches. Nature offers an endless array of scenic backdrops, and kids can't resist the call of the wild. Before you try to catch them in action,

light or when used with the flash.

Film speeds can range from as low as ISO 25 to as high as ISO 3200, although most automatic cameras only accept a limited number of speeds, usually ranging from ISO 100 to 400.

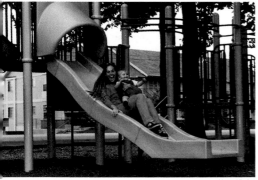

Alyssa Allgaier

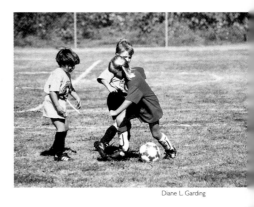

Diane L. Garding

brush up on the basics of film speed, prefocusing, and outdoor flash.

Film speed is a measure of film's sensitivity to light. The more sensitive, or fast, it is, the higher its ISO (International Standards Organization) number. Faster films require less light to give a good exposure, making them the prime choice for action shots. The trade-off, however, is that the faster the film, the coarser the print. Low speed films work best in bright

To photograph action with an automatic camera, use ISO 400 film, and prefocus on a fixed spot before pressing the shutter button.

For general purpose photography in a wide variety of lighting conditions, ISO 200 usually does the trick, but go for ISO 400 when shooting more action-oriented images. Assuming your camera can handle even higher speeds,

such as ISO 800, try them for low-light situations when you don't want to use the flash, and for super-fast action shots.

These are just general guidelines. Experiment on your own with different film speeds. The results you get will be affected by factors including the type of lighting in your home, where you are geographically (sunny California or rainy London), and the season you're shooting in.

Once you've settled on a film speed, confront the real challenge of shooting outdoor activities: freezing movement. Compact cameras automatically focus on whatever is in the center of the frame. But with all the excitement going on in, for example, a soccer game, nobody stays still for very long. To ensure that your shots come out sharp, even when your subjects are off-center, prefocus: Situate a fixed object in the center of your frame and half-depress the shutter button. Then, with your finger still on the button, recompose your composition, so that, at the right moment, click!

Using your flash can improve your outdoor photographs. Some compacts come with a fill-flash feature, which flashes with less intensity than a full flash, thereby helping to illuminate faces without washing them out with too much light. If your camera doesn't come equipped with a fill-flash option, try using the regular flash. If you think there will be too much light, reduce its power by waving a finger in front of the flash as you take the picture or veiling it with a thin layer of tissue paper.

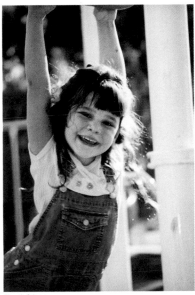
Rhonda Solomon

Outdoor photography can find your child in the neighborhood playground, at the majestic Grand Canyon, and anywhere in between.

Kelli Ann Collins

A Swirl of Leaves

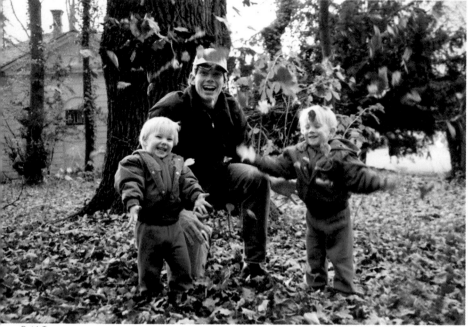

Desirée Tanner

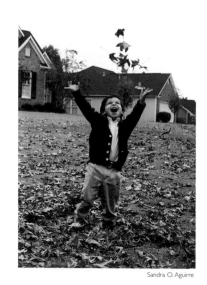

Sandra O. Aguirre

Red, orange, and yellow leaves punctuate your photos with rich colors. Let the flying foliage fill the frame. To get some great autumn pictures, aim to photograph your child's every move:

- squatting down to grab some leaves
- springing up with fists full
- scattering leaves high into the air

When you happen on a freshly raked pile, get out your camera, and let the kids go! (If it's a neighbor's pile, keep in mind the advice to "shoot now, discipline later." Be sure to repair the damage.)

Fun variation: Kneel or sit and shoot the leaves—and kids—against the sky.

Use Dappled Light TIP #**53**

Dappled, evenly diffused sunlight filtered through a canopy of leafy tree branches can cast your child in a soft, golden light that a flash would cancel out. To use dappled light:

- Shoot in the open shade (shade where light filters through).
- Don't be afraid of shadows.
- Experiment.
- If the light looks too contrasty, especially on the child's face, it will look worse on film; ask the subject to move a little.

Smart tip: Learn how to turn off your camera's flash before you experiment with this technique. I took this

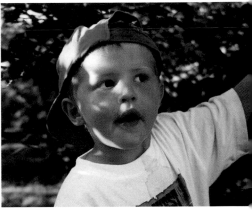

Lisa Bearnson

picture of Collin the day after I got my new camera and didn't yet know how to turn the flash on! I accidentally discovered this technique.

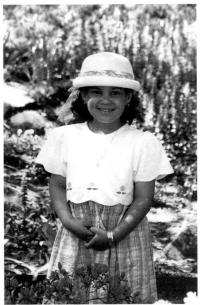

Carol A. Cousins

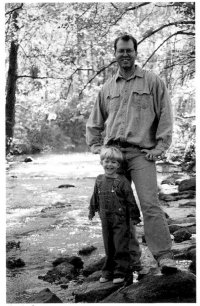

Angelyn Bryce

FUN AND GAMES IN THE GREAT OUTDOORS

Get in the Water

Sometimes you gotta get wet for the photo you want! Just be careful to keep your camera dry. A waterproof model or protective covering over your regular camera stops moisture from seeping inside the casing. Water and sand are leading causes of camera damage, so take care.

- Use the flash to freeze splashing water and eliminate the shadows of high-noon sunshine.
- For shots taken near a stream or at the beach or lake, frame

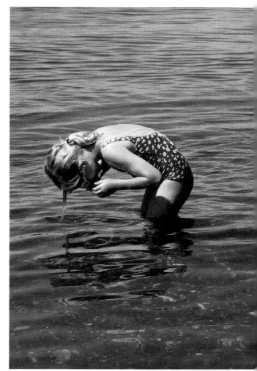

Diane L. Garding

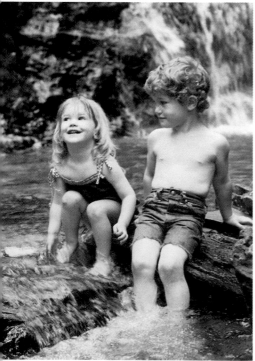

Joyce Hill Schweitzer

your children with elements characteristic of the environment.

For the best lighting conditions, shoot water photos at the beginning or end of the day. One exception is underwater photography shot with a waterproof camera. High-noon sunlight best illuminates the aquatic environment.

Smart tip: Even if your camera is water-safe, don't leave it out in the sun for long. If it gets too hot, the colors in the film will be affected.

Look for a Curve

Lisa Bearnson

urves convey movement and lead the eye through the image. Noticing curves may take some practice. Look for them in:

- winding backroads, garden walkways, and rambling trails
- river bends as well as coves, lakes, and ponds
- footbridges and archways
- amusement park rides

Rides usually follow a curving track, and I used a curve in the circular boat ride to get a feeling of motion in this picture of Collin and his cousin Tyler. In taking this shot, I realized I had several chances to get a cute facial expression because the ride passed the same spot many times. This is the one I like best. Some rides even slow down slightly, making it easier to get a focused shot and to fill the frame with oncoming kiddies.

Dianne L. Gottron

71

Kids in Hats

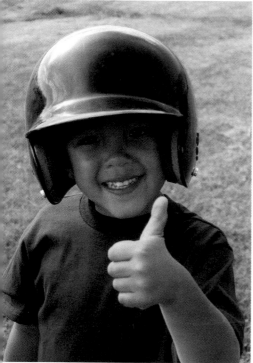

Kristina P. Caldwell

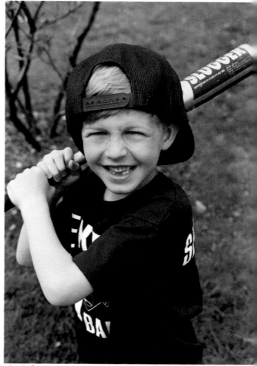

Angelyn Bryce

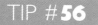ats—baseball caps, baby bonnets, straw boaters—create a frame within a frame, reinforcing the emphasis on your child's face. In the photos above, the boys' blue baseball gear stands out against the background of green grass, further enhancing the composition.

Consider the different perspectives for pictures of kids with hats.

- If you shoot from above, looking down on your child, the emphasis will be on his youthfulness—even if he's doing a very grown-up thing.

- If you shoot your child at his own level, eye to eye, it will give him a solid confidence in the frame. In the photo at left, mom filled the frame with her son's radiant emotion after he got on first base. Instead of being sheepish, she ran right onto the field to get this shot.

- If you shoot from below, the photo will convey an air of pride and accomplishment.

Projects with Dad

Whether fixing a flat tire or flying a kite, dads bring a can-do spirit to the great outdoors. As soon as father and child are fully engrossed in the task at hand, snap some candids. Project photos capture parenting in action.

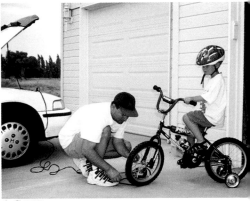

Brenée K. Williams

- Shoot horizontals to record telling details of everyday life.
- Include bright colors to add impact outdoors.
- Freeze movement with medium-to-fast ISO 200 or 400 film.
- Use your camera's fill-flash mode to give objects a sharper outline when shooting from a low angle.
- Get in front of the activity so you can shoot the approaching team.

Smart tip: Don't let your auto focus camera focus on the background between two figures. Focus first with one person at the center, readjust your composition, and click.

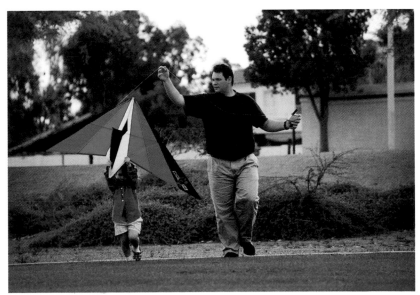

Rhonda Solomon

FUN AND GAMES IN THE GREAT OUTDOORS

Silhouettes

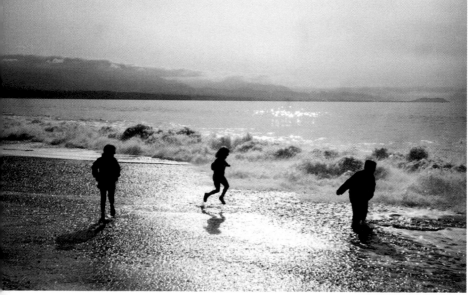

Diane L. Garding

Silhouetting is simpler than it seems. The trick? Shoot with the sun behind your subject and don't use a flash. For dramatic silhouettes, let your kids get between the sun and your camera.

- Shoot from late afternoon until dusk, when the glow of the departed sun still lights the early evening sky.
- To make the most of the fading daylight, shoot in wide open spaces, such as on hilltops or beaches. Avoid objects, such as treetops, that might block the rays.
- Give each subject his or her own space so that they all photograph as separate individuals.
- Turn off the automatic flash.

With practice, you'll discover that the drama and moodiness of silhouettes can sometimes communicate as much emotion as traditional portraits.

Maureen Graney

Photos of Motion

eady, set, go! For high-energy shots, anticipate the action and get in close.

- Turn off the red-eye protector. It delays release of the shutter.
- Assume a low position and shoot up to exaggerate the perspective.
- Leave space around your subject in case of minor errors in timing.
- Load your camera with the fastest film it can handle (ISO 400 or 800). You'll get the best results when you shoot on a bright day.

Deanna Lambson

Deanna Lambson

- Use your flash to freeze motion.
- Anticipate a peak moment—a brief pause in the motion—before pushing the button.

In these photos, mom caught her Jumping Jack, above, the split second before he began his descent; the swinger at left has reached the end of his arc and is on the brink of heading back. If shots end up blurred, don't consider them failures! Blurred images, particularly ones with bright colors, convey a sense of motion.

FUN AND GAMES IN THE GREAT OUTDOORS

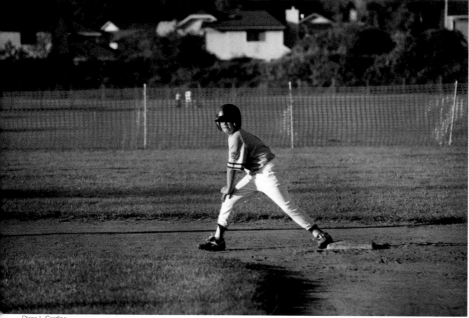

Diane L. Garding

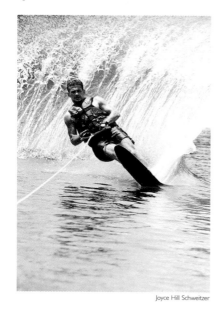

Joyce Hill Schweitzer

You have to shoot a lot of frames to get perfect action shots. So while you're shooting, aim for added impact by framing your subjects in a range of angles. Some options:

■ **Close-up:** Athlete is front and center, as in these photos. Fill the frame with your zoom, or get close.

■ **Sideline:** The main subject is on one side balanced by other participants or excited fans on the other.

■ **Pan:** Move the camera along with the action. The subject stays in the same place in relation to the camera, but all other background features blur into dramatic streaks.

Young Scientists at Work

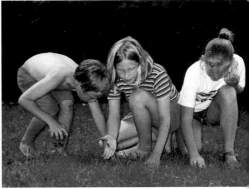

Angela S. Barrus

F ield research—beachcombing, butterfly catching, birdwatching—engages young scientists to such an extent that you can catch them absorbed in their observations.

Note the natural, yet balanced, composition of the children in these photos. The overlapping arms and legs of the trio at right emphasizes team spirit. These three budding biologists form a fluid horizontal line between the bright green grass and the dark green background trees. Below, in their upside-down triangle pose, each child gets his or her own space within the frame because the height of the heads varies.

■ If the sun is behind your subjects, try to shoot from a shaded area or shade your lens with your hand.

■ To reduce facial shadows caused by the sun, use the fill flash.

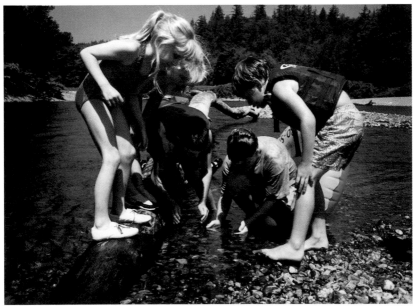

Angela S. Barrus

FUN AND GAMES IN THE GREAT OUTDOORS

77

Let It Snow

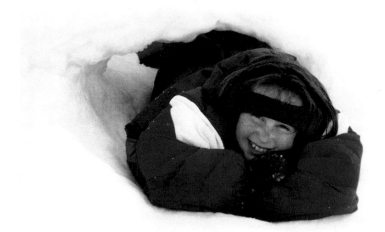

Jeannette R. Hewlett

Light reflected back from snow-scapes tricks the automatic camera's meter into underexposing the image. The result? Dingy snow. While some compact cameras include a feature that can be set to overexpose, and thus lighten, the scene, most do not. For naturally whiter whites:

- Shoot in bright conditions.
- Use the flash.
- Dominate the composition with a vividly colored subject. The camera's meter in both photos calibrated to the ski outfits. This let the moms avoid underexposing the surrounding snow.
- The snow tunnel above acted as a giant light reflector, illuminating the girl all around.

Smart tip: Batteries burn out more quickly in the cold. Have extras on hand to be safe.

Carol A. Cousins

Strong Solid Backgrounds

Strong, unusual colors make great graphic backgrounds for your photos. If they contrast with your child's clothing, they'll really stand out.

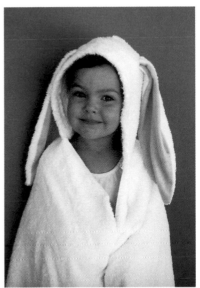

- Large areas of solid color are hard to find. When you see one, reach for your camera.
- If the color background is outside, you have a better chance of capturing the hue on film.

This kind of photo tests the quality of your photo developer. Every photo negative can be printed hundreds of different ways. If your picture doesn't capture the color you saw, try getting a reprint at a better shop.

Lanae B. Johnson

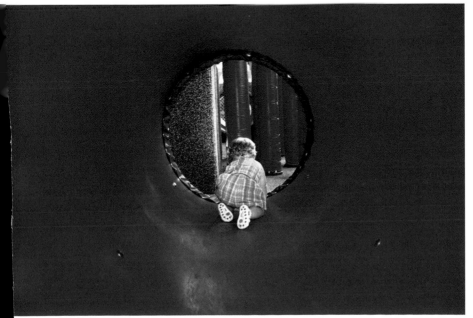

Alyssa Allgaier

Neutral Backgrounds

Gale A. Johnson-Peltier

Lisa Beamson

Neutral backgrounds, such as the cool concrete pavement at left and the warm camel color of the barn interior below, can be effective backdrops. They add atmosphere and pleasing texture to an image without overwhelming the subject.

Clothes count when backgrounds are neutral. At bottom, Brecken's bright red shirt makes the photo. It stands out against the pale golden hay and, paired with her overalls, complements the farm theme.

- Restrict your color palette to a few strong hues.
- Before shooting, frame your composition so that distracting colors on the fringes are cropped out.
- Look for geometric shapes that draw attention to your subject. The rectangular blocks above and barn boards below seem to propel the children forward.
- Experiment with light to emphasize textures such as pebbled sidewalks, straw-scattered floors, and roughhewn boards without casting your subject in unflattering shadows.

Fun tip: Shoot from a position where you can see light striking the surface from the top or the side. Texture will be most prominent when light shines almost parallel to the surface.

Nature's rich colors and organic textures are timeless. The girl at right could almost be camouflaged among the blonde wheat shafts, but her red rake and bright plaid shirt bring her to the fore. Below, you feel the calm a serene New England landscape brings to a young girl. For similar effects:

Lynette L. Staker

- Keep clothes and accessories classic; plan outfits for fun shots like the wheat-field scene at top.
- For close-ups, situate your child among elements that repeat simple shapes and patterns.
- Look for naturally occurring subject planes in the landscape (foreground, middle ground, and background). Then make your child the single, central point of interest.

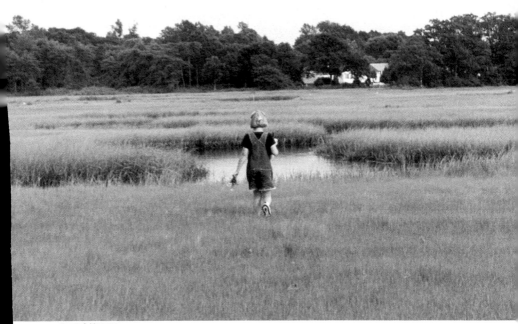

Annette B. Mortensen

Exploring Nature

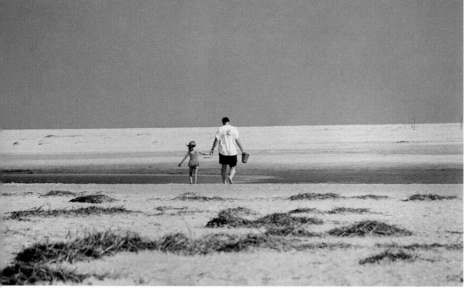

Angelyn Bryce

Rhonda Solomon

oments of parental tenderness combine well with natural settings. Think of your child experiencing the beauty of the natural world protected by a loved one, and compose your shot:

- Include visually appealing elements in the foreground, such as the slight rise of the dune and scattered seaweed, above.
- Shoot at different times of day to experiment with the light and to create silhouettes.
- Look for graphically strong repeating patterns, such as rocks in a forest stream, and well-defined areas above and below a horizon.

The Romantic Landscape

o re-create your feeling of awe at a spectacular nature setting, try making the people a small part of the photo, much as the Romantic painters of the nineteenth century did. Consider two examples:

Lisa Bearnson

- In the picture of Kade at right, your eye automatically goes to his red shirt as you notice his relative smallness in the scene. I shot from below, which helped show how tall the falls were. Note that a brief shutter setting can freeze rivulets of flowing water, while a slower speed causes them to blur.
- Below, the presence of father and child does not disturb the grand scene. Stones add graphic interest.

Maureen Graney

GATHER

GROUP PHOTOS

TOGETHER

Hail, hail, the gang's all here, and how often does that happen? Group photos present challenges to even the most seasoned photographer, but, when done right, they become the pictures that friends will cherish forever.

Some compositional tactics can strengthen the impact of group photos. People sitting in an interesting arrangement around a central area look more active than plunked in the middle of the picture, for example. If people are doing something or looking at each other, you feel more engaged with the shot. Horizontal photos emphasize background details, whereas vertical photos tend to make you pay attention to the center.

When people look at a photo, they automatically look at the eyes of the subjects. If the children in a group are of greatly varying heights, the viewer will be bouncing all over the photo trying to make eye contact with each one. Try to find creative ways to arrange all the faces at approximately the same level. Alternately, a triangular configuration takes the viewer in steps around

all three points of the triangle. For examples of this technique, see Tip #74.

One of the most useful rules of composition, the intersection of thirds, explained way back in Tip #24, merits repeating. If you divide your image both horizontally and vertically into thirds, any element positioned on one of those lines, and particularly one of their four meeting points, stands out.

It's fun to take a few photos as the group gathers itself. All that fumbling and shuffling might make for a comic montage building up to the "official" portrait. Check through the viewfinder for any missing hands or legs, any hidden heads, and, of course, for any objects that shouldn't be there (see "false attachment," page 37). After you've established your composition, check up on team spirit. If the gang exhibits some awkwardness with each other, or if their energy is beginning to lag, loosen things up by introducing a topic of conversation that's sure to provoke some passionate reactions. Then give yourself a solid safety margin by snapping several shots. The more kids, the tougher it is to catch

each and every face clearly. Someone's always sneezing, or yawning, or blinking, right when the camera clicks.

When shooting large groups, particularly if you're also trying to place them within the context of a scenic background, the wide-angle setting of your zoom will help you to squeeze it all in without having to stand ten miles away. By rendering sharp details from front to back, rather than compressing perspective, as a telephoto lens would, wide-angles help to create a sense of depth. Maximize this effect further by keeping the camera close to your foreground subject—but not too close, as

Hang time: The matching uniforms and poses of these three add a solid symmetry to the image, but each boy also makes the photo his own with a unique expression.

you would with a head-and-shoulders portrait because the wide angle will distort facial features. By the same token, be careful not to place anybody at the far edges of the frame because the wide angle stretches and warps these border areas.

So now, gather everyone together and have a great time!

GROUP PHOTOS: GATHER TOGETHER

All Together Now

onkey see, monkey do! Add some attitude to group shots by encouraging kids to strike the same pose or make the same funny face in a game of photographic Simon Says. Duplicate gestures give much-needed unity and focus to a group shot. But kids being kids, each one will still find a way to make the moment his or her own, and these individual antics play up personalities delightfully.

- Shoot at eye level.
- Allow a little overlap. Touching shoulders, for example, suggest the closeness of Brecken, Collin, and Kade.
- Avoid distracting backgrounds that might lead the eye out of the frame.

- Incorporate details that will reinforce the symmetry. Consider having your group pop up over a fence or peek out from behind the stalks in a cornfield.
- Give them something similar to wear—the swimming goggles below, the necklace that two of the four are wearing at right. Take advantage of similar dress. Arrange kids in sports gear or school uniforms, or simply keep clothes in the same category—three boys in pajamas, four girls in dresses.
- Leave room near the edges in group shots to avoid cropping anyone out. Follow framing guidelines (parallax correction marks) if your camera has them.

Lisa Bearnson

Angelyn Bryce

Angelyn Bryce

A Great Big Hug

Family portraits that show children in their Sunday best, proudly standing stiff as boards, are important parts of your family photo collection. But try something different for a more casual group portrait: a hug.

A hug changes a traditional small-group shot. Gone is the awkward stance and forced smile, replaced by genuine affection and enthusiasm.

- Get in close with the camera: three-quarter body shots capture

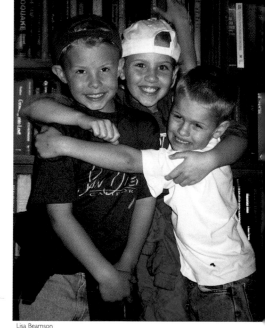

Lisa Bearnson

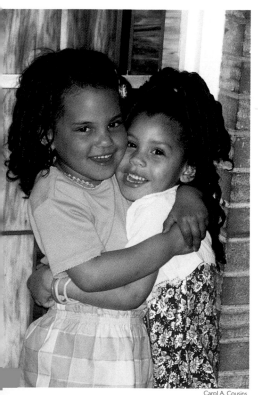

Carol A. Cousins

the immediacy of the embrace. Be careful not to crop out any arms!

- Keep heads at about the same level. If one child is significantly taller than the others, arrange the children so that the difference is not so noticeable. This way, the viewer won't have to look all over an image to make eye contact with the different individuals.

- Without stage-directing a pose that will break the spontaneity of the squeeze, ask the kids to look toward the camera. Take several shots.

A Tiny Kiss

otcha! Get the designated kisser in on the joke before you take the shot, then capture the look of sweet surprise that graces the face of the recipient of a "spontaneous" smooch. From the aw-shucks embarrassment of a boyfriend to the innocent affection between kindergarten classmates, photos of kisses convey pure emotion.

Joyce Hill Schweitzer

- For younger kids, choose classic childhood settings, such as the flower garden below, that speak to the timelessness of puppy love.
- Teenagers look more relaxed and natural if, instead of posing them, you catch them off guard when they're distracted by an activity.

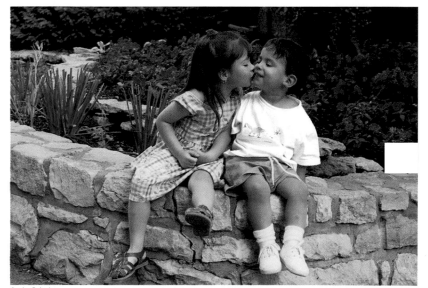

Sandra O. Aguirre

Dress Them Alike

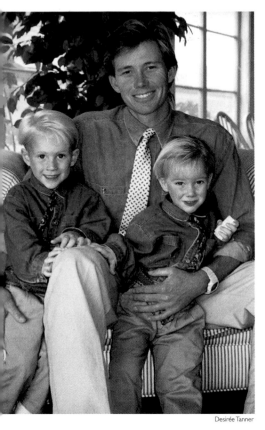

Desirée Tanner

Clothes of the same cut and color strengthen the impact of a group shot.

- The uniformity of style states that the individuals are members of the same family, team, or school.
- The dominant hue grabs the viewer's attention.
- The color also imparts an emotion to the scene. For example, denim blue gives the portrait at left a calm, casual formality. High-energy red show the two kids below are raring to go.

Approach a duo differently than a group. With nearly mirror-image poses and roughly the same eye level, the twosome below show they're equal partners in play. In all group photos, each sitter needs his or her own head space, and in larger groups one person should be the obvious center. Above, it's Dad, with others clustered around.

In either case, encourage the kids to interact with each other. Great big hugs, tiny kisses, and clasped hands all express a bond. Subjects shouldn't always look directly at the camera because the way they regard each other reveals a lot, too. To catch these glances, take several practice shots as the participants are getting into position.

Fun variation: Professional portrait photographers love dressing everyone in white for photos on the beach.

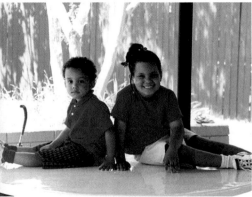

Carol A. Cousins

Dress Them Different

Julie C. Egan

n the other hand . . . it's not so much a question of dressing everybody differently. It's about using color to distinguish one person from another. In the photo above, all five children wear the same type of fleece jacket. The five rainbow shades all stand out, although the orange and yellow pack the most punch. Blue jeans unify the base of the composition.

At right, the bright colors—turquoise, lemon, melon, and red—punctuate the neutral landscape. The mom (who's in the photo) planned the shot—even buying everyone the same shirt in different colors—though a friend pressed the shutter button.

- Try giving each person a different color to wear.
- Keep clothing simple; trendy details make the image look dated quickly and distract the viewer.

Kathy Hewlett and Clydene Forbush

91

Where You Are in the World

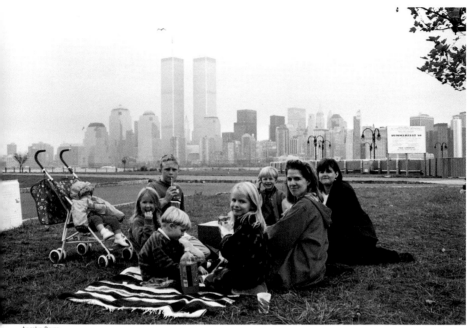

Angelyn Bryce

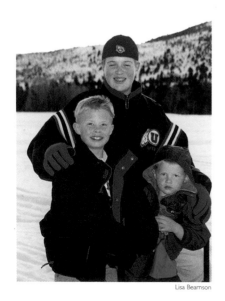

Lisa Bearnson

Prove to the world you were there, and improve your versions of these classic travel photos.

■ To balance people and scenery, situate your subjects a third of the way into the frame, and leave the remaining two-thirds for the breathtaking backdrop. Be sure to prefocus on the people in the center of the frame first, before recomposing the scene and pressing the button.

■ If your camera is so equipped, experiment with the wide angle of the zoom range, to capture more of the scene and to emphasize scale.

Look for a Triangle

Group photos that assemble people in a triangular shape direct the viewer's attention from the base to the peak and back down again. It's an easy format for ensuring each person has his or her own head space.

- Encourage contact among the individuals to unify the area of interest, as at right.
- In spite of the predetermined pyramid structure, once your sitters are in position, get them to loosen up. In the photo below, the boy clowning around in the foreground gives this image its personality.

Marty L. Hinojosa

Joyce Hill Schweitzer

A Jumble of Cousins

These pile-ups illustrate many of the key points of group photographs:

- Everybody needs his or her own head space.
- Body contact emphasizes closeness.
- Horizontal framing incorporates background details.

To foster informality in group portraits, issue a fun challenge, such as "Everybody on the grass!" In the photo at top, I asked everyone to show how tired they felt after our day at an amusement park. I watched the reac-

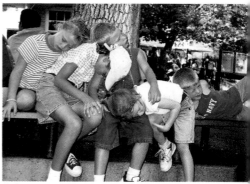

Lisa Bearnson

tions and kept on shooting. This picture always makes me think they were really fast asleep—only Collin peeked, giving the game away!

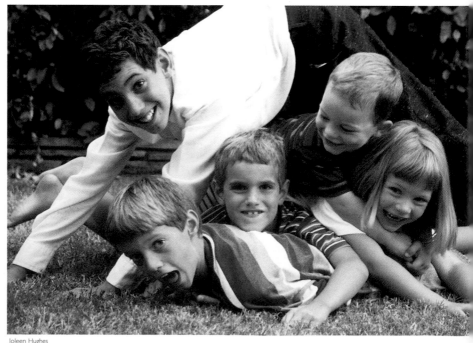

Joleen Hughes

Index

Numbers in **boldface** indicate photographs